IMAGES

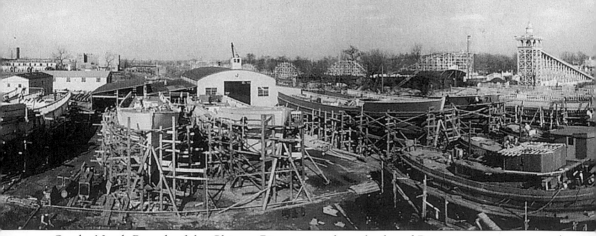

On the North Branch of the Chicago River, across from the famed Riverview amusement park, was located one of Chicago's must enduring shipyards, the Henry Grebe Shipyard. During World War II the company produced wooden submarine chasers.

IMAGES
of America

MARITIME
CHICAGO

Theodore J. Karamanski and Deane Tank Sr.

ARCADIA

Copyright © 2000 by Theodore J. Karamanski and Deane Tank Sr.
ISBN 0-7385-0761-X

First Printed 2000.
Reprinted 2001, 2003.

Published by Arcadia Publishing,
an imprint of Tempus Publishing, Inc.
3047 N. Lincoln Ave., Suite 410
Chicago, IL 60657

Printed in Great Britain.
Published in cooperation with the Chicago Maritime Society.

Library of Congress Catalog Card Number: 00-105234

For all general information contact Arcadia Publishing at:
Telephone 843-853-2070
Fax 843-853-0044
E-Mail sales@arcadiapublishing.com

For customer service and orders:
Toll-Free 1-888-313-2665

Visit us on the internet at http://www.arcadiapublishing.com

CONTENTS

ACKNOWLEDGMENTS

This book is made possible by the commitment of the people of the Chicago Maritime Society. Since 1982, hundreds of members, volunteers, and contributors have played a role in building the society's collections and programs. While we cannot acknowledge each one by name, the involvement of each helped to make this book a reality.

Of direct assistance in making this book a reality were Lori Grove, the photographic archivist of the Chicago Maritime Society and Carl Neal, the society's photographer. As in so many of our graphic enterprises over the years, Thomas Willcockson played a role—in this case by preparing two wonderful line drawings. The authors also wish to acknowledge the contributions to Chicago maritime history of John I. Laudermilk, Philip Elmes, and Ralph Frese.

While most of the images in the book are from the society's photographic collection, we wish to acknowledge the gracious permission of sister institutions in allowing us to publish some material from their collections: Marine Historical Collections, Milwaukee Public Library, Chicago Historical Society, the National Archives, and the United States Army Corps of Engineers. We also wish to thank David R. Phillips for permission to use some of the wonderful images in his collection of 19th century photographs.

For all things related to the *Eastland* tragedy, we are indebted to David Nelson who has been a leader in identifying and preserving the history of that sad event.

INTRODUCTION

At the beginning of the last century, Chicago was the busiest port on the Great Lakes, and one of the busiest in the world. In total tonnage, Chicago bested all ports, save London, New York, and Hamburg. Yet unlike those great port cities, and scores of small towns along the shores of the inland seas, Chicago has no institution dedicated to its illustrious maritime history. The purpose of this book is to demonstrate graphically the significance, diversity, and drama of maritime Chicago—to make the case in pictures that this past deserves a place in the present.

Chicago's maritime history is significant because waterways determined the location of the city. In 1818 the boundary of Illinois, on the eve of statehood, was adjusted northward to include the southern tip of Lake Michigan so that one state could control the vital link between the Great Lakes and the Mississippi River system. Before Chicago had become Daniel Burnham's "City Beautiful" or Carl Sandburg's "Hog butcher to the world," the city was toasted as the "Queen of the Lakes," home to a harbor that saw hundreds of white-winged ships arrive and depart each day.

The maritime story of Chicago is diverse, because it is the story of the Great Lakes and the Chicago River, of the downtown port and Lake Calumet, of basins shaped by God, and glaciers and canals carved out of the limestone by dint of human labor, of beaches, deep tunnels, and pumping stations. The maritime story is also as diversely peopled as the modern city, from Indian canoeists, to Norwegian schoonermen, to Bohemian and African-American lumbershovers. The docks of Chicago were a threshold across which worlds met, for immigrants from Europe, for slaves being secreted across the lakes to Canada, for Midwesterners getting their first look at a Japanese car being unloaded at Navy Pier in the 1960s.

Maritime Chicago is a dramatic story of urban growth and regional transformation. It is a story of traumatic environmental engineering and visionary landscape sculpting by means of piers, dredges, and land fills. It is the high drama of Chicago's Christmas Tree Ship of 1913 sinking with all hands on the open, gale-swept lake, and the memorable tragedy of the *Eastland*, when more than eight hundred lives were lost only a few feet from shore.

The Chicago Maritime Society offers these pictures in the spirit of discovery. We hope that Chicagoans and maritime historians will find in these pages new images and stories that present the Midwest's largest city from a fresh perspective. All images used in this book are part of the collection of the Chicago Maritime Society unless otherwise noted. For nearly 20 years, the Chicago Maritime Society has been collecting and preserving the memories, pictures, and artifacts of the city's nautical past. This book is a small sample of the trove we hold in trust, a down payment on a richer, more graphic story we would like to tell in a Chicago maritime museum.

One
Canoe to Checagou
Frontier Chicago

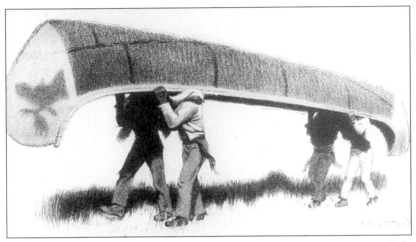

Chicago's maritime history begins with the American Indians. In historic times many different native peoples called Chicago home, including the Illinois, Miami, Ottawa, and Potawatomi. All of these people were masters of the art of canoe building. While there were other types of canoes made by the Indians, the most adaptable and useful were the birchbark canoes. Rolls of birchbark were peeled off of trees and sewn together over a wooden frame. Pine pitch was used to seal the seams. The finished product had the advantage of being relatively lightweight, highly maneuverable, and capable of bearing considerable cargoes. Best of all, such canoes could be repaired during the course of a journey with materials readily available in the Great Lakes region.

Indians used the canoes to undertake trading journeys to distant tribes. By the 1600s French fur traders in Canada had begun to adopt the canoe as a means of exploring the interior of North America. Canoes provided the means of transportation for Father Jacques Marquette, the Jesuit priest, who in 1673 was the first European to visit the Chicago area. Marquette later spent the winter of 1674–1675 in Chicago, in a camp near the present site of where the Damen Avenue bridge spans the Sanitary and Ship Canal. Although the missionary died just a few weeks after his sojourn in Chicago, other French missionaries and traders followed him. For both Indian and French fur traders Chicago was the site of an important portage, linking Lake Michigan with the Des Plaines River via the South Branch of the Chicago River.

During the 18th and early 19th centuries, Chicago evolved from being merely the site of a portage for the fur trade canoes, to the site of an important trading post. Jean Baptiste Pont Du Sable, a merchant of mixed African and French parentage, was the first to appreciate the business value of Chicago. By 1779 he had established a successful trading post in cooperation with the Potawatomi Indians, who lived along the North Branch of the Chicago River. Other fur traders followed, and by the 1820s Chicago was the most successful trading area on Lake Michigan.

The canoe only slowly gave way to larger wooden boats and rigged sailing ships. Even in the 1830s canoes still often offered the most efficient way to move people and goods in frontier Illinois. It was the building of the Illinois and Michigan Canal, which took from 1836 to 1848, that brought an end to the canoe era and ushered in the emergence of Chicago as a budding port city.

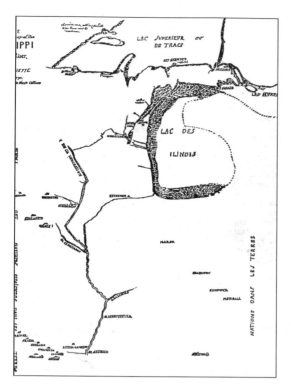

This is the first map to show the area that became Chicago. It was made by Jacques Marquette, S.J. in 1674, shortly after completing his exploration of the Mississippi and Illinois River valleys. Lake Michigan was called Lac Des Illinois by the French.

Of all the items of Indian manufacture, the canoe became the most widely used by the European-Americans. (From Henry Rowe Schoolcraft, *Travels Through the Northwestern Regions of the United States*, Albany, 1821.)

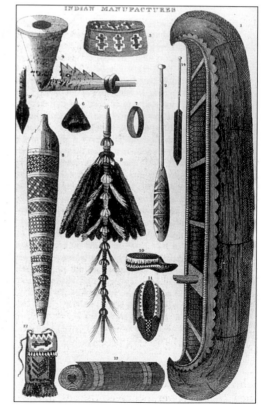

This is Chicago as it might have looked in 1779, only the Du Sable cabin and Indian dwellings were present.

John Kinzie came to Chicago in 1804 as a fur trader. His house, located on the north bank of the Chicago River, occupied the site of the old Du Sable cabin.

Canoes were particularly suited to travel through a wilderness area, because they could be repaired with materials readily available in the forests of the Great Lakes region. (From *Outing Magazine*, 1905.)

For long journeys on the Great Lakes, canoes could be fitted with sails to take advantage of following winds. The need for greater and greater cargo capacity and the desire to improve sailing qualities led to the canoe being gradually replaced, first by wooden boats known as *bateaux* and later by schooners. (From *Outing Magazine*, 1902.)

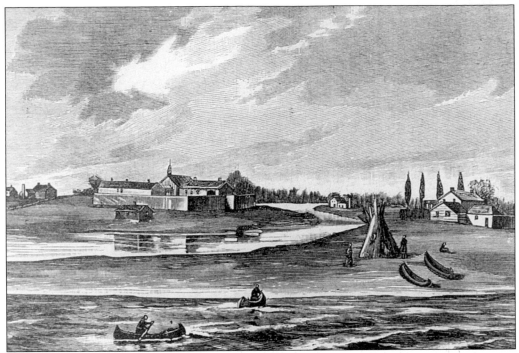

Fort Dearborn, located near the present site of the Michigan Avenue bridge, was founded in 1803. It was destroyed by Potawatomi and Ottawa Indians at the start of the War of 1812, and was rebuilt in 1816.

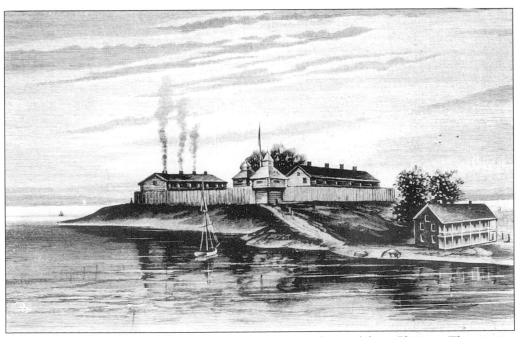

Even as late as 1830, canoes were still important to travel to and from Chicago. This picture illustrates Fort Dearborn located at the mouth of the Chicago River (near today's Michigan Avenue bridge).

Gurdon S. Hubbard came to Chicago as a teenage fur trader. He found crossing the Chicago portage a very laborious undertaking. At one point the fur traders had to haul their outfit through a bog. "Those who waded through the mud frequently sank to their waist, and at times were forced to cling to the side of the boat to prevent going over their heads; after reaching the end and camping for the night came the task of ridding themselves of the blood suckers." Hubbard later recalled that the bloodsuckers "stuck so tight to the skin that....experience taught the use of a decoction of tobacco to remove them."

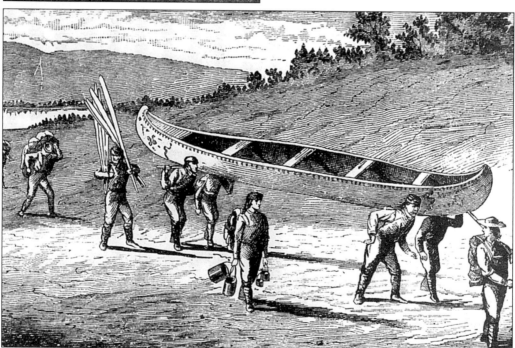

A typical fur trade portage is pictured above. (From H.H. Robinson, *The Great Fur Land*, New York, 1879.)

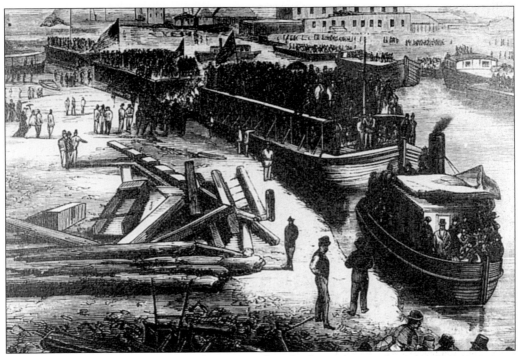

The opening of the Illinois and Michigan Canal made the portage no longer necessary.

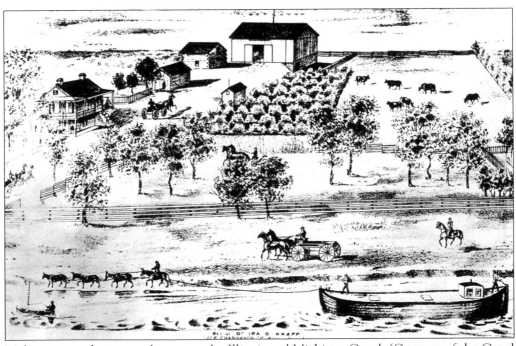

Mules were used to power barges on the Illinois and Michigan Canal. (Courtesy of the Canal Archives, Lewis University.)

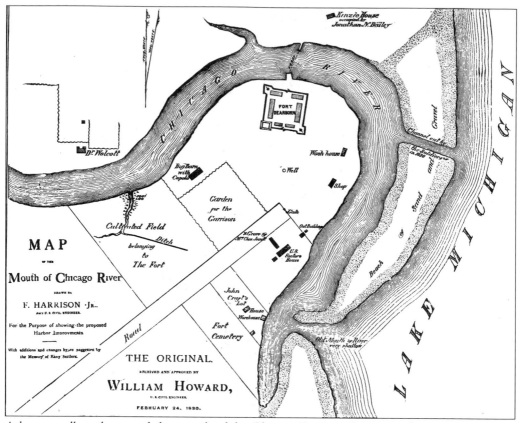

MAP
OF THE
Mouth of Chicago River
DRAWN BY
F. HARRISON ·JR.·
ASST U. S. CIVIL ENGINEER.

For the Purpose of showing the proposed
Harbor Improvments

With additions and changes by us suggested by
the Memory of Many Settlers.

THE ORIGINAL.
RECEIVED AND APPROVED BY
WILLIAM HOWARD,
U. S. CIVIL ENGINEER.
FEBRUARY 24, 1830.

A large sandbar obstructed the mouth of the Chicago River and prevented vessels larger than a canoe or rowboat from using the river as a harbor of refuge. Soldiers from Fort Dearborn first tried to dig a channel through the bar in 1828.

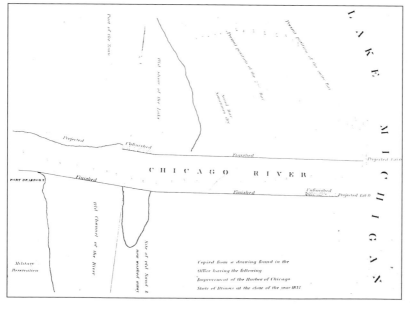

Beginning in 1834 the United States Army Corps of Engineers worked to open a passage through the sand bar and clear the way for Chicago to be a port city. Although the harbor was created in 1835, sand would be a recurring problem throughout the 19th century.

Two

SCHOONER CITY

CHICAGO IN THE AGE OF SAIL

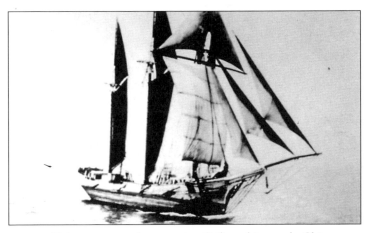

Nineteenth century Chicago was a schooner city. Sailing ships made Chicago one of the world's busiest ports. In 1871, the year of the Great Fire, more ships arrived in Chicago than in New York, San Francisco, Philadelphia, Baltimore, Charleston, and Mobile, combined. Schooners made up the bulk of the sailing fleet and were responsible for the rise of two of the city's earliest and greatest industries: the grain trade and the lumber trade. The latter was largely a traffic between Chicago and other smaller Lake Michigan ports. During the years after the Civil War, lumber centers in Michigan and Wisconsin such as Muskegon, Manistique, Menominee, and Green Bay annually sent hundreds of schooner loads of lumber to the Chicago market. Well into the 20th century schooners continued to play an important role in the transportation of lumber. The last Lake Michigan schooner, *Our Son*, foundered in September 1930 carrying a cargo of lumber. The grain trade did not remain under sail nearly so long. By the late 1880s, steamships had wrestled the bulk of the grain trade from schooners. Yet during the half-century when schooners were the principle means by which Chicago's giant grain market was linked to the rest of the world, the city's finest sailing ships were dedicated to the trade. While the lumber schooners were seldom under sail between ports more than a couple of days, the grain trade required longer hauls. A typical run between Chicago and the head of lake navigation at Buffalo, New York took ten days. The best schooner captains were those who could safely speed their vessels eastward and carve a day or two off that time. Every day saved meant the possibility of making another voyage before ice and storms closed the lakes in December. After unloading their cargoes of grain at Buffalo, the schooners would have their holds filled with Pennsylvania coal to fuel the furnaces of Chicago through the long winter.

Schooners were well-suited to Chicago's 19th century port, the narrow Chicago River. Theodore Dreiser called it "the smallest and busiest river in the world." The sailing ships were seldom more than two hundred feet in length, and therefore could be maneuvered by tugboats far up the branches of the river, as deep into the city as Bridgeport. Businesses and industry crowded along the banks of the Chicago River in order to have direct access to the ships. Saloons and boarding houses near the docks solicited the patronage of the thousands of sailors who made Chicago their homeport. As many as five hundred vessels would winter in the Chicago River, taking advantage of the city's numerous shipyards to make the repairs or improvements needed for next shipping season.

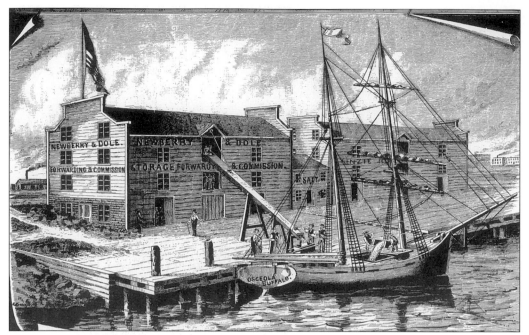

The first shipment of grain from Chicago was made in 1839. The ship employed was the *Osceola*. Like many of the early sailing ships to visit Chicago, the *Osceola* was rigged as a brigantine—a ship with a square sail hung from the foremast, and gaff, or fore-and-aft rig on the mizzen mast.

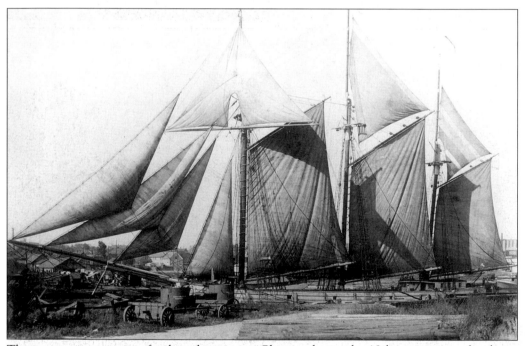

The most common type of sailing ship to visit Chicago during the 19th century was the three-masted schooner. A schooner is a fore-and-aft rigged ship with two or more masts. Pictured here is the *Lucia A. Simpson* under full sail. (Courtesy of the Marine Historical Collection, Milwaukee Public Library.)

18

The most dangerous place for a sailor to work was in the "cross-trees." Located high above the deck, where the lower mast met the topmast, the "cross-trees" consisted of a small platform. From this precarious perch the seaman had to deploy the topsails and repair any spars and lines that required maintenance. (Courtesy of the Michigan Maritime Museum.)

The *Lucia A. Simpson* was a typical Great Lakes schooner. The picture illustrates the appearance of the deck, looking from the stern toward the bow. The raised structure on the deck was the cabin, where the captain and mate slept, and the crew took their meals. The crew slept in the forecastle, below decks in the bow.

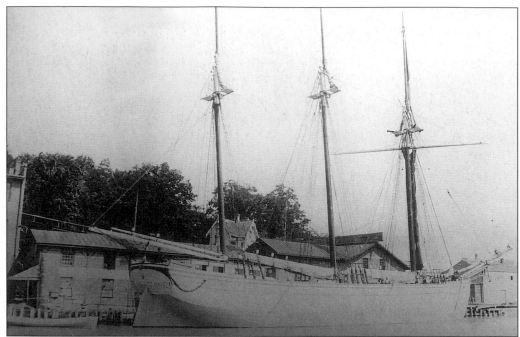

The schooner *Edward Blake* takes on a cargo of lumber at a small lake port. Note the spar hung perpendicular to the foremast. It was used to deploy a triangular sail known as a raffee. It was unique to the Great Lakes and gave schooners sailing before a following wind the pulling power of a square sail. (Courtesy of the Great Lakes Marine Historical Collection, Milwaukee Public Library.)

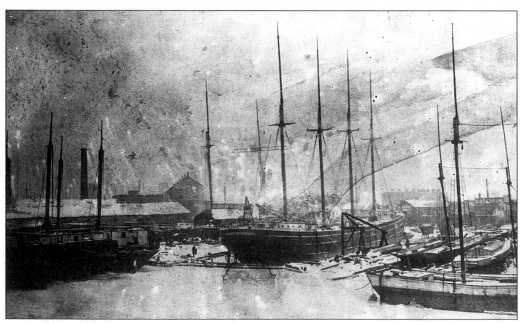

Shipbuilding began in Chicago with the construction of the *Clarissa* in 1834. Goose Island, on the North Branch of the Chicago River, was the center for early shipbuilding. Pictured here is the Miller Brothers Shipyard, the city's largest builder of wooden ships. In the dry dock is a rare four-masted sailing ship. (Courtesy of the Chicago Historical Society.)

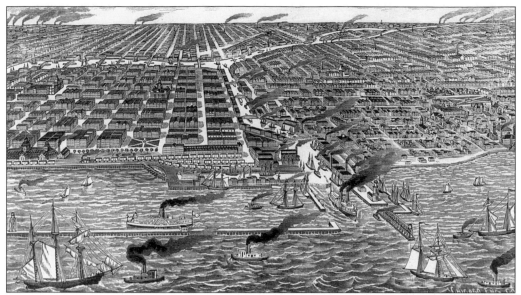

The Port of Chicago reached its peak of activity and importance during the 1870s and 1880s. This bird's-eye view captures the heavy volume of sailing ship traffic and the key role of the tugboats bringing them into and out of the river harbor. (Courtesy of the Chicago Historical Society.)

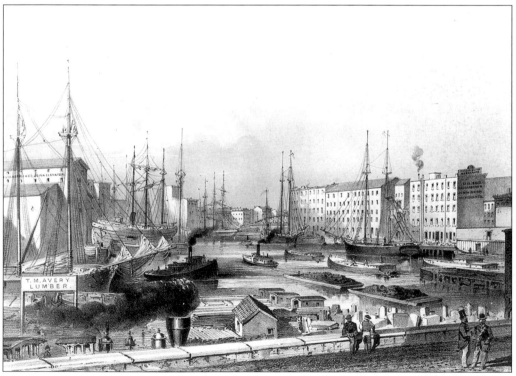

The busy South Branch of the Chicago River often resembled a forest of masts. Canal boats and barges from the Illinois and Michigan Canal added to the congestion. During the 1880s, the Port of Chicago would handle 20,000 ship clearances annually. (Courtesy of the Chicago Historical Society.)

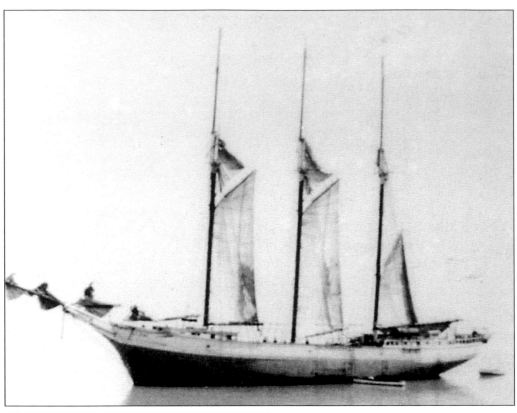

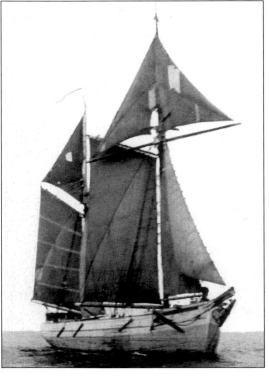

There were several different types of lake schooners. The most common were the clipper schooners, like the *George Boyce*. When new, these vessels were generally employed in the grain trade, hauling heartland harvests from Chicago to Buffalo, New York. Great Lakes Clipper Schooners were initially developed by William Wallace Bates of Manitowoc, Wisconsin, in 1852.

Canaler schooners lacked the sleek lines and steady sailing ability of the clippers. Built to fit the limitations of the Welland and St. Lawrence River canals, the canalers had flat bottoms and stubby bowsprits. They were notoriously bad at weathering heavy gales.

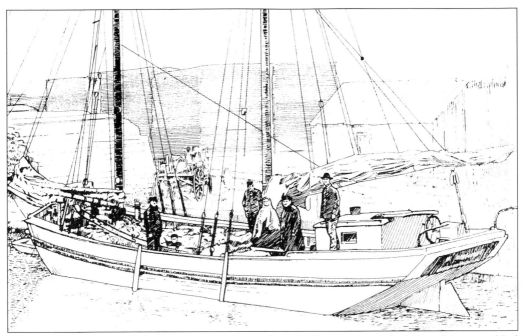

Scow schooners boasted flat bottoms and squarish ends. Some sailors joked that they resembled floating boxes. They were both easy and cheap to build. Scow schooners were popular in the lumber trade as their shallow draft made them well-adapted to access the unimproved lumber towns along the margins of northern Lake Michigan. This sketch was drawn by Thomas Willcockson from a photograph in the Michigan Maritime Museum.

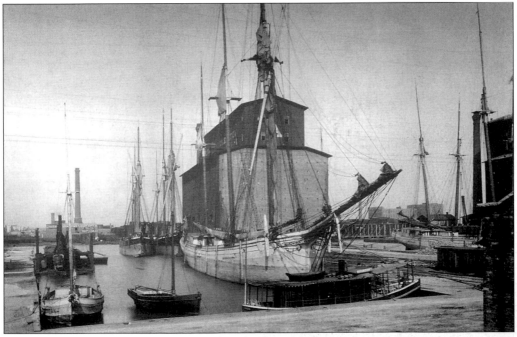

Chicago grain schooners are awaiting their load in the Illinois Central Railroad slip, c. 1886. (Courtesy of David R. Phillips.)

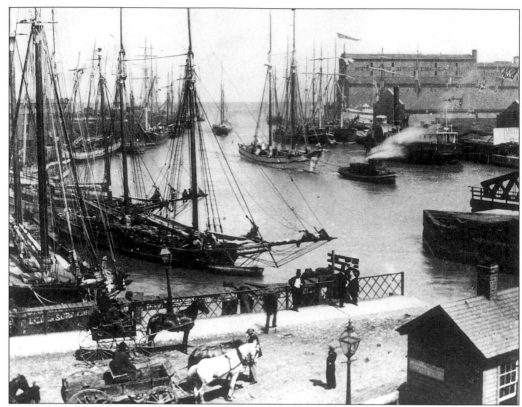

The Rush Street bridge swings open to allow a tugboat to pull a lumber schooner up to Wolf Point. Scores of schooners unload their cargoes at the lumberyards and grain elevators that lined the mouth of the Chicago River. Meanwhile, pedestrians and carriages wait impatiently for the span to close again.

In 1830, the forks of the Chicago River were little removed from the wilderness. The location was given the name Wolf Point when a prairie wolf was shot invading the smokehouse of Elijah Wentworth's tavern.

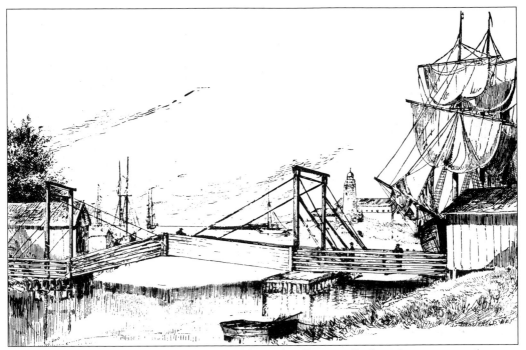

The Dearborn Street drawbridge was one of the early efforts at affording ships access to the river and pedestrians easy movement from the north side to the south side of the city. Built in 1834, the hoisting mechanism frequently broke, and the span was notorious for fouling the rigging of passing sailing ships. The bridge was torn down in 1839, much to the relief of south side property owners, who did not want the north side of the river to develop commercially.

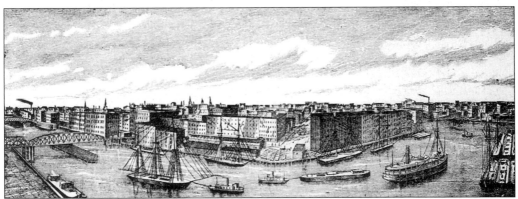

By 1870, schooner traffic had transformed Chicago into the leading city of the west. Wolf Point became the site of the Lumber Exchange, where all cargoes of lumber entering the river were inspected and sold. It was not unusual for one hundred vessels a day to register at Wolf Point.

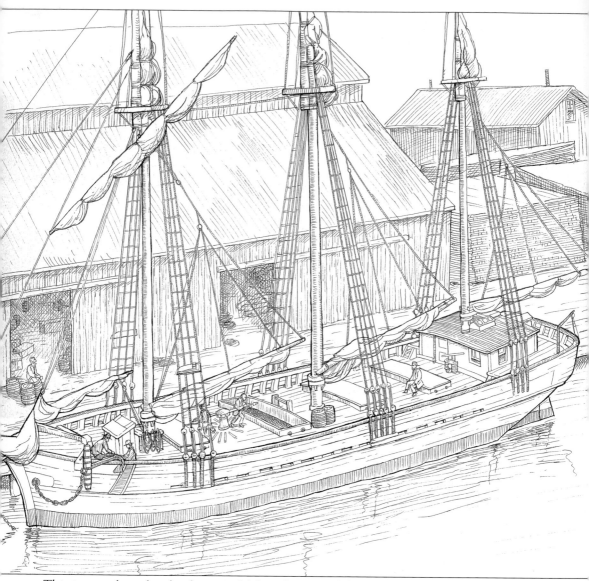

This is a modern sketch of a typical lake schooner of the 1880s. Among the most important features of the schooner were its large rectangular hatches that gave access to the hold of the ship. Schooners were bulk-carriers. Grain ships were loaded with their cargo at the side of giant grain elevators. Spouts lowered from the elevators emptied the golden stream into the hold. Loading schooners with lumber was a much more laborious process. On the dock of the Chicago lumber district, the work was done by a class of workers know as "lumbershovers." In smaller ports the crew of the schooner might be required to help load the vessel. Note the windlass operated by two men on the deck of the schooner. This device was of considerable assistance in lifting lumber from the hold to the dock.

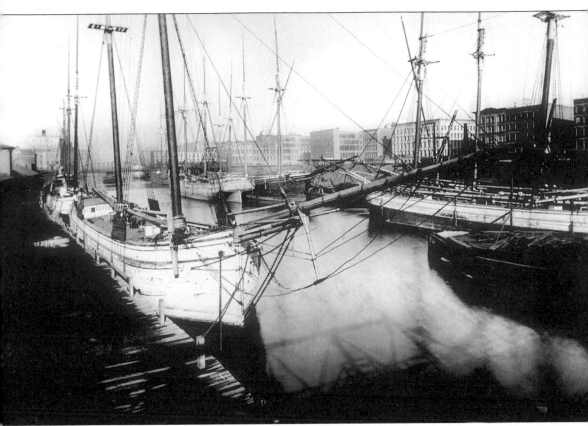

A trip to Chicago often entailed several sets of tugboat charges for the schooner's master. City statute required that all schooners entering or exiting the harbor had to do so under tow, to reduce the possibility of a collision. Ships often required an additional tow to take on a new cargo for their return voyage. Such charges often were the largest single fixed cost of an entire round-trip to and from Chicago. (Courtesy of David Phillips.)

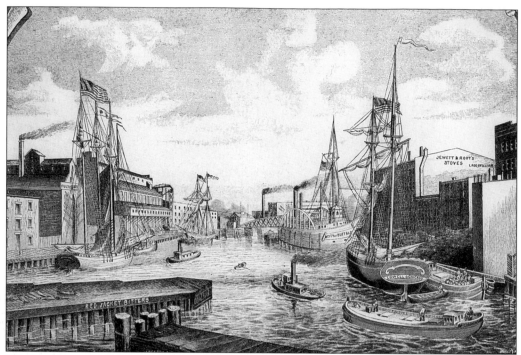

The busy Port of Chicago was the meeting place of lake vessels, railroads, and canal boats. This allowed the city to easily tap the produce and products of the rest of the Midwest and allowed Chicago merchants to sell their products to a national marketplace. In this illustration from the 1880s, the schooner *Lowell* accepts a cargo from a canal boat while a tugboat takes a second canal boat up the river to the head of the Illinois and Michigan Canal at Bridgeport.

At the mouth of the Chicago River (as pictured here in a c.1890 photograph) and on the west side of Chicago in the Pilsen neighborhood were the great lumberyards of the city. During the years after the Civil War, at least nine thousand schooners of lumber had to be unloaded each year. An English visitor in the 1880s remarked that "timber yards are a considerable part of the city's surface, there appearing to be enough boards and planks piled up to supply a half-dozen states."

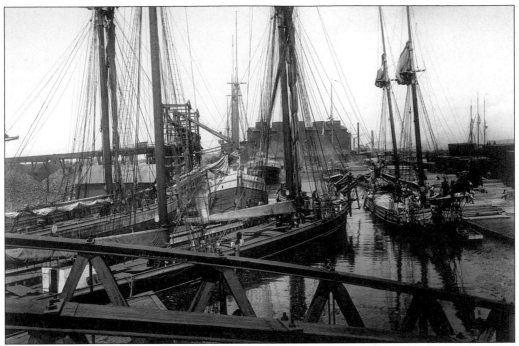

The veritable forest of masts was a frequent sight along the wharfs and slips of the west side lumber district. To the right in the photograph, lumbershovers unload a two-masted schooner.

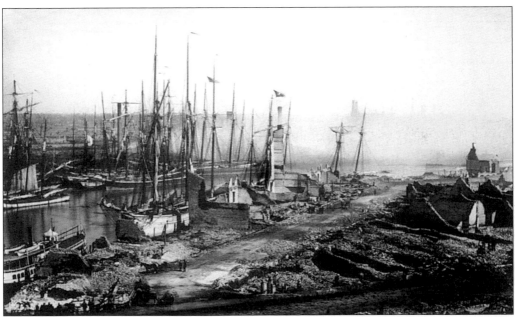

Chicago's demand for lumber grew even greater after the 1871 fire that burned the central business district and the north side of the city. Even before the ashes cooled, schooners arrived with cargoes of new building materials to shelter the homeless.

The last ships to dock in Chicago at the conclusion of the shipping season were the Christmas Tree Ships. The late November-early December voyages were extremely hazardous. From 1887 to 1918, Herman Schuenemann or his family sold Christmas trees from the deck of a schooner tied up at the Rush Street bridge. Captain Schuenemann perished with all his crew in 1912 when the schooner *Rouse Simmons* succumbed to an icy blizzard off the Wisconsin shore.

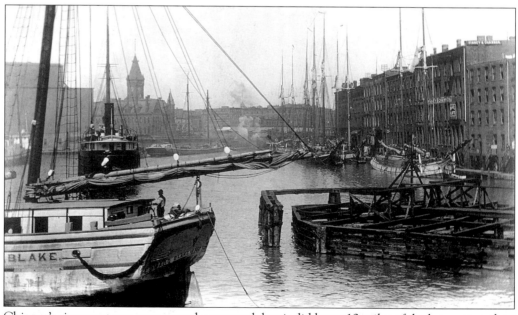

Chicago's river port was narrow and congested, but it did boast 12 miles of dockage, more than most cities with large natural harbors. (Courtesy of David Phillips.)

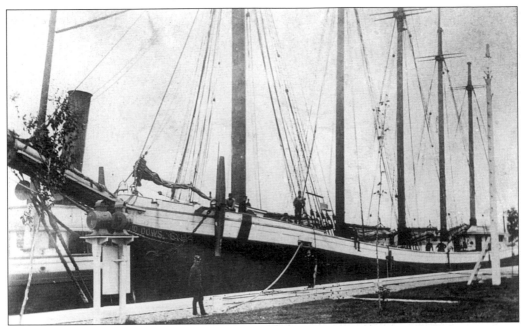

The *David Dows* was the largest sailing ship to frequent Chicago. Built in 1881, the *Dows* was 275 feet long and mounted five masts. She was an attempt by wooden shipbuilders to match the efficiencies of the larger steel steamships. Steam hoists were used to raise her sails, and larger cargo hatches made her an easy ship to load or unload. The *Dows* met her end in November 1889, in an icy gale off South Chicago. (Courtesy of the Marine Historical Collection, Milwaukee Public Library.)

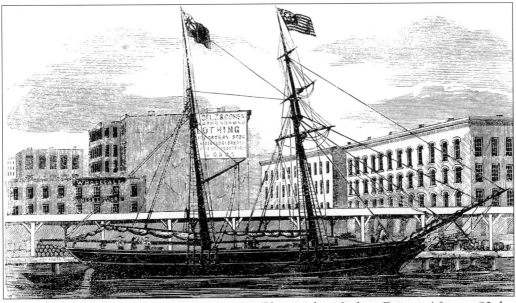

The *Madeira Pet* was the first ship to arrive in Chicago directly from Europe. After an 80-day voyage, the British brigantine docked with a cargo of china and other luxury goods on July 14, 1857. One hundred years before the St. Lawrence Seaway, the Welland Canal, in what is now Ontario, linked the Upper Great Lakes with Lake Ontario and the Atlantic Ocean.

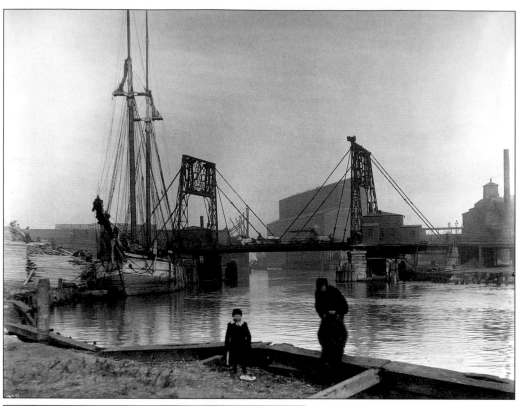

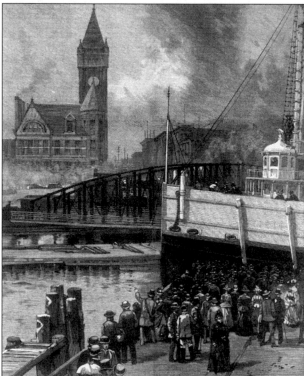

Chicago's river port was bridged by more spans than any other harbor in the world. Pictured here is a drawbridge on the North Branch of the Chicago River.

The location of Chicago's dynamic harbor in the heart of the city was a frequent source of frustration for pedestrians and teamsters. On a single day in 1854, a total of 24,000 pedestrians and 6,000 teams of horses crossed the Clark Street bridge. Yet during that same day, a hundred ships passed the bridge requiring the bridge to swing open for a total of three hours. Such inconvenience made many Chicagoans embrace proposals to relocate the city's harbor to South Chicago.

Three

STEAMBOATS AND STEEL HULLS

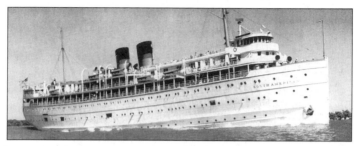

"The lakes have never known a static trade," observed maritime historian Walter Havighurst. For more than a half-century the schooners dominated the Port of Chicago, but throughout the long age of sail on Lake Michigan, steamships gradually assumed more and more of the trade. The schooner men disparaged the smoke belching vessels that first stole the passenger trade from the sailing ships, and then during the 1880s and 1890s gradually drove the schooners from their niche as the region's bulk carriers. "Dey used to be lots of damn good sailors," complained Captain Fred Taylor, Master of *Our Son*, the last of the Lake Michigan schooners, "Now it's all steamboats and dey take harbor rats aboard and leave the real sailors without a job—wat you tink dis country's coming to?"

Steampower brought reliability to the movement of people and products on the lakes. To a much greater extent, sailing ships had been subject to the whims of weather, whereas steamboats operated on the tight schedules that suited an industrializing nation. The first steam-powered vessel on Lake Michigan was the *Walk-in-the-Water*, which in 1821 brought United States Army troops from Detroit to Green Bay. The first steamers were paddle wheel vessels. In 1841 Great Lakes shipbuilders began to experiment with propeller-driven ships. This design competed with the paddle wheel into the 1860s, when the propeller-driven vessels became dominant among steamships, on the lakes as well as on the oceans.

The first iron-hulled ship on the Great Lakes was the *U.S.S. Michigan*, launched in 1843. She more than proved the utility of iron in marine building by remaining in active service longer than any other iron-hulled ship. In 1861 the first commercial iron-hulled ship, the *Merchant*, began her career of 20 years of service on the lakes. *Merchant* eventually came to grief on the Racine Reef and rests today on the bottom of Lake Michigan. Although iron-hulled ships demonstrated their utility early, the abundance of forest products in the Great Lakes region ensured that wooden-hulled ships would continue to be built all through the 19th century. Beginning in 1889 steel-hulled bulk carriers began to make their appearance. This was the future of the lake marine, and in the 20th century, steel ships as passenger carriers, package steamers, and as bulk carriers ruled the lakes.

The Chicago Shipbuilding Company, located in South Chicago, was one of the most notable builders of steel ships for the lake trade. In March of 1891 the company launched the *Marina*, the first steel-hulled ship built on Lake Michigan. The also built many barges and were the first to do away with sails on barges, since it was increasingly difficult to find crews who were experienced with the older technology. As steel became the preferred building material for ships, the size of vessels quickly became larger and larger. A typical wooden freighter measured 250 feet in length. By 1906 steel lakers were 600 feet in length. The result was a decline in the large number of small ships, as a diminished fleet of giants dominated the lakes. Lakers built today are in the 1,000 foot range.

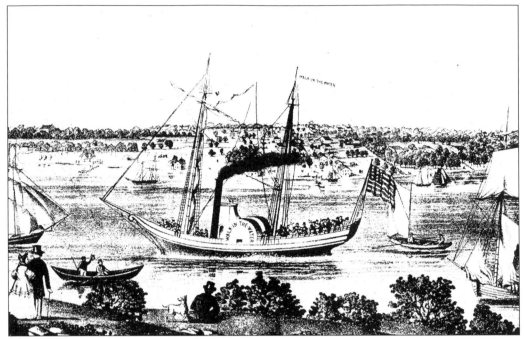

The *Walk-in-the-Water* was built in 1818 and was the first steam vessel to successfully navigate on the lakes. In 1821 she entered Lake Michigan for the first time.

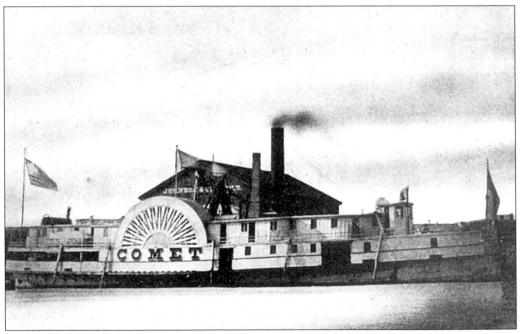

The *Comet* was a side-wheel steamer that helped to pioneer regularly scheduled passenger service on Lake Michigan. During the 1850s and 1860s she was a regular visitor to Chicago when she served as the flagship of the Goodrich Steamboat Line. Known for her reliability, the *Comet* never succumbed to the hazards of navigating the inland seas. She was eventually taken out of service in November 1869 and was dismantled.

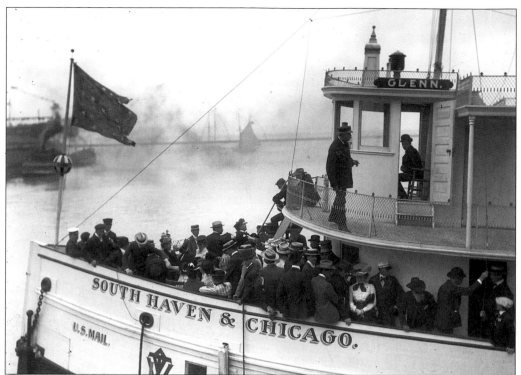

Among the most popular passenger routes was across the lake from Chicago to the Michigan ports of South Haven and Glen Haven. Excursion ships such as the *Glenn* brought tourists for weekend visits and returned with cargoes of fresh fruit from the orchards of southwestern Michigan. (Courtesy of the Chicago Historical Society.)

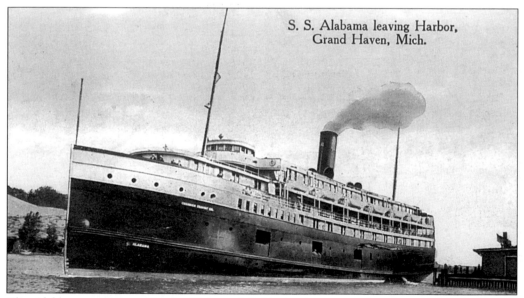

The *Alabama* participated in the Chicago-Michigan passenger and package trade. Note cargo doors amidships. These doors were located at dock level and would swing open upon arrival in Chicago to unload crates of peaches, cherries, and apples.

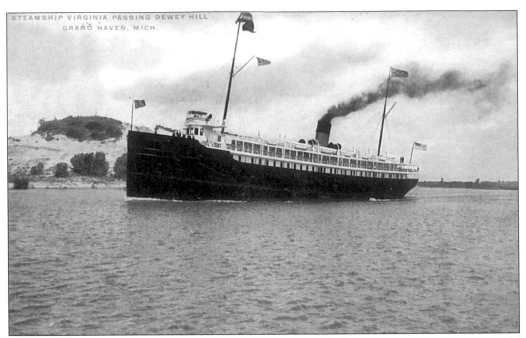

The *Virginia* was a 285-foot steamship that was fitted-up with sleeping compartments so it could operate as a night boat between Chicago, Grand Haven, and Muskegon.

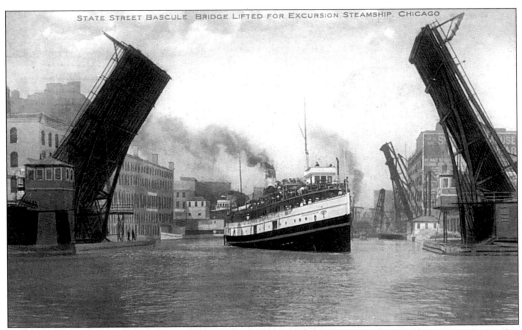

Passenger and package steamers like this one in the Chicago River were part of a spectacular revival of passenger and freight business on the Great Lakes during the early 20th century. Rather than competing with the railroads, the steamers worked in conjunction with them, promoting tourism to areas also served by the railroads and by carrying freight for the train lines. In 1907 steamers carried 6,650,000 tons of packages for the railroads.

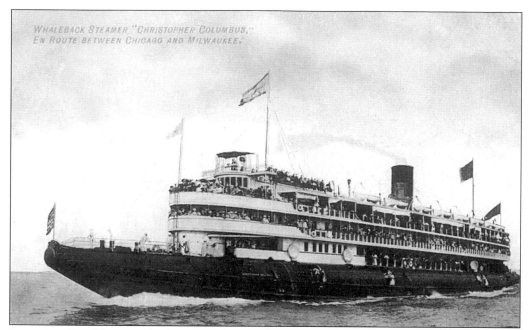

For more than 20 years, the largest and most elegant of Chicago's excursion steamers was the *Christopher Columbus*. She was the only whaleback steamer adapted to serve as a passenger vessel.

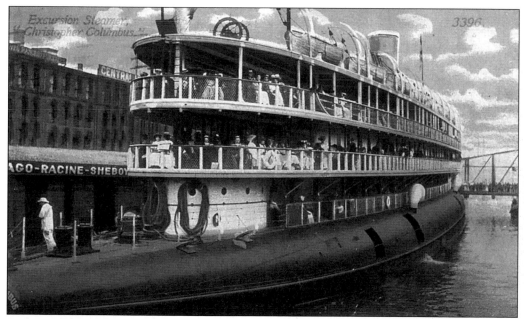

Built in 1893 in the record time of just over three months, the *Christopher Columbus* was 362 feet long with five thousand-horsepower engines that allowed her to cruise at a speed of 18 miles per hour.

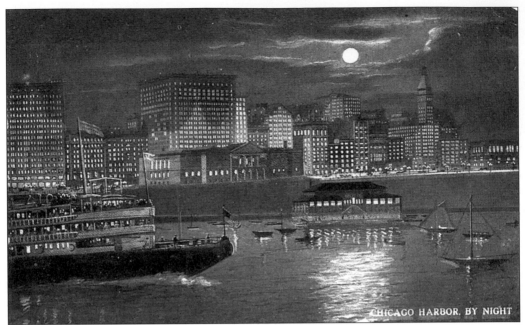

CHICAGO HARBOR. BY NIGHT

The *Christopher Columbus* was brought into service in time to accommodate the crowds of Midwesterners who thronged to the World's Columbian Exposition. During the fair she ferried visitors from downtown Chicago to the fairgrounds in Jackson Park. She was capable of carrying five thousand people at one time, and during the fair she carried more than two million passengers.

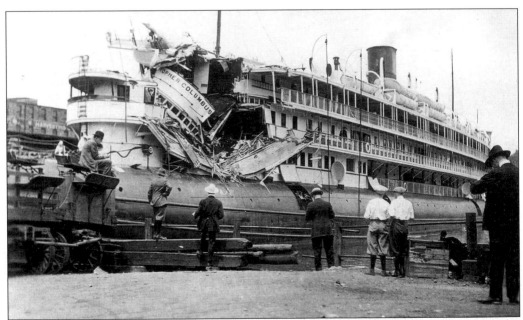

Only once in her proud 44-year history did the *Christopher Columbus* suffer a serious mishap. In June of 1917, careless handling by Milwaukee tugboats led to a collision between the ship and a water tower. Sixteen people were killed. In 1937, after another 20 years of service, the *Christopher Columbus* was sold for scrap to Japan. To what use her steel was put at that time can only be imagined. (Marine Historical Collection, Milwaukee Public Library.)

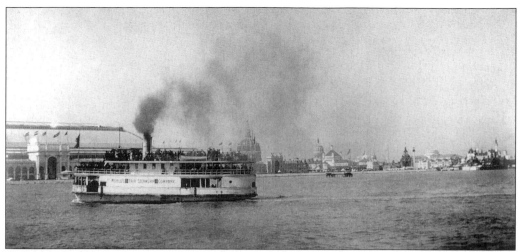

Numerous vessels smaller than the *Christopher Columbus* were also employed in bringing visitors to the World's Fair.

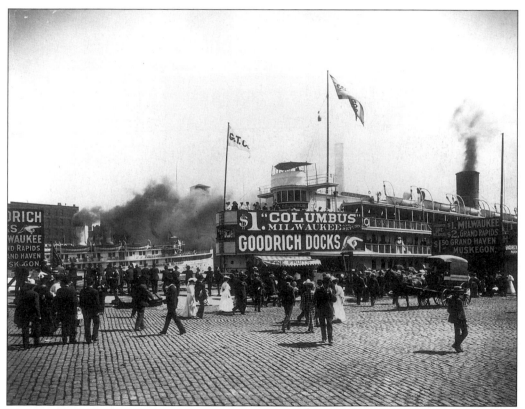

The Goodrich Transit Company operated the *Christopher Columbus* during most of its history. Here the ship awaits its passengers at the Goodrich Company's Rush Street dock. (Courtesy of the Chicago Historical Society.)

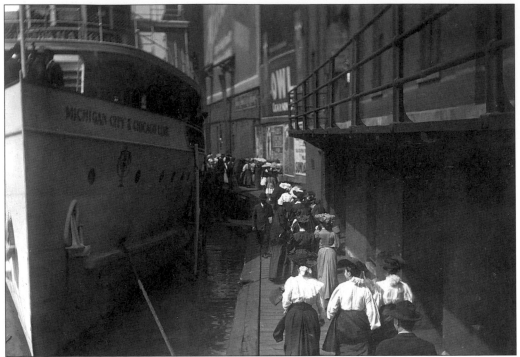

Men and women in their Sunday best crowd the narrow dock to board an excursion steamer for Michigan. (Courtesy of the Chicago Historical Society.)

Reading newspapers and smoking cigarettes help passengers aboard a steamer bound for Michigan pass the time, in about 1900. (Courtesy of the Chicago Historical Society.)

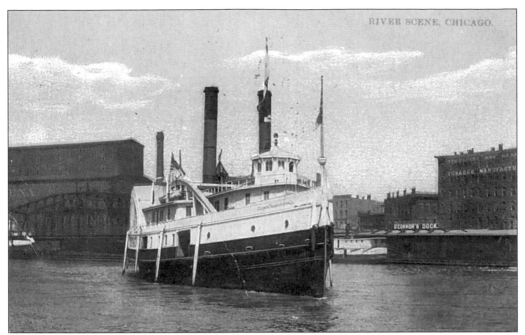

In 1912 a steamer of the Chicago Transportation Company, its long wooden fenders deployed along its side, prepares to dock in the Chicago River.

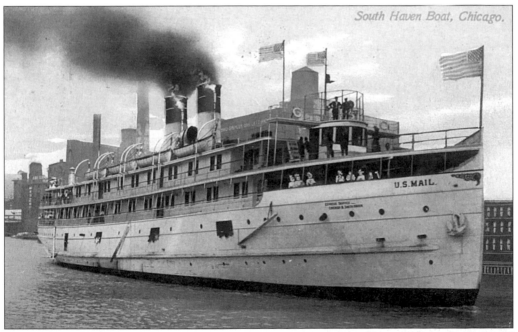

A steamer of the Chicago and South Haven Line cruises out of the Chicago River. Federal mail contracts combined with passengers, packages, and fruit to make these cross-lake runs profitable turn-of-the-century businesses.

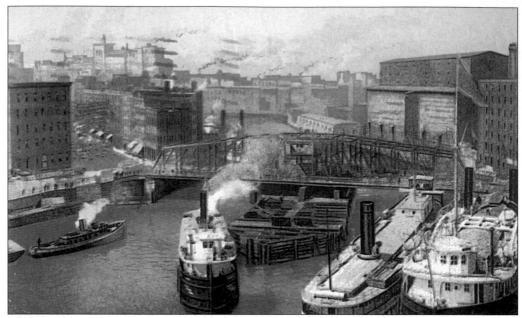

As late as 1910 the volume of shipping at Chicago, measured in the number of ships arriving and departing, exceeded any port in North America and rivaled the great harbors of the world, such as London and Hamburg.

The ever-growing size of the new steel steamers made navigation in the narrow confines of the Chicago River increasingly difficult during the first years of the 20th century.

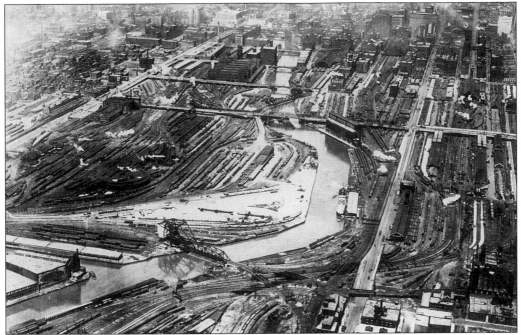

In 1890 the United States Army Corps of Engineers began to try to bring order to the chaotically managed river. Obstructions to navigation along the stream were removed. When one angry property owner complained "the Lord never intended large boats to go above Canal Street," the general chairing the hearing curtly answered, "There is no evidence as to that before this body."

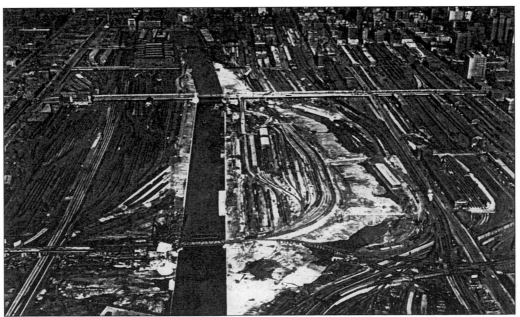

A long-term project was to straighten the South Branch of the Chicago River. It was not begun until 1926 and was not completed until 1930. The pictures here illustrate the river before and after the straightening project.

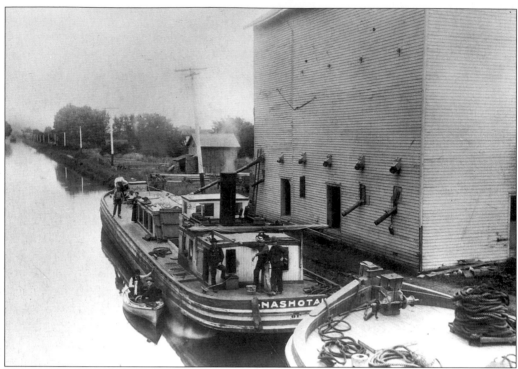

Illinois and Michigan Canal boats also made the transition to steam power. The old canal reached the peak of use during the 1880s, when its replacement, the Ship and Sanitary Canal, was planned. (Courtesy of the Canal Archives, Lewis University.)

At the mouth of the Chicago River in 1902, the paddlewheel steamer *USS Michigan* passes wooden sailing ships and a sleek new steel passenger ship.

One of the busiest places on the Chicago River was at the Halsted Street lift-bridge. Diverse industries were crowded along this stretch of water, from lumberyards and steel mills, to chocolate makers and glass works.

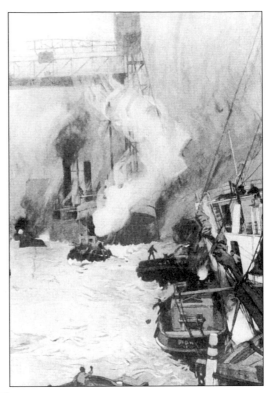

The port required thousands of stevedores, who were disparagingly referred to as "dockwhallopers." These seasonal laborers frequently called wildcat strikes during the peak of the shipping season to boost their wages.

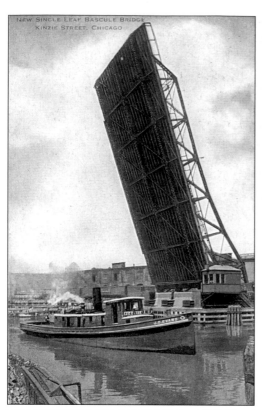

The workhorses of the Chicago harbor were the tugboats. During the 1870s, a tow from outside the breakwater to a berth in the river could cost as much as $25.

During slack periods in the economy, which were frequent in the 1890s, tugboats desperate to recruit work would sometimes steam out as far as Milwaukee to find schooners in need of a harbor tow.

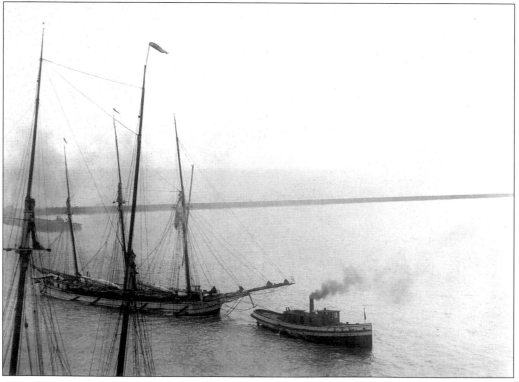

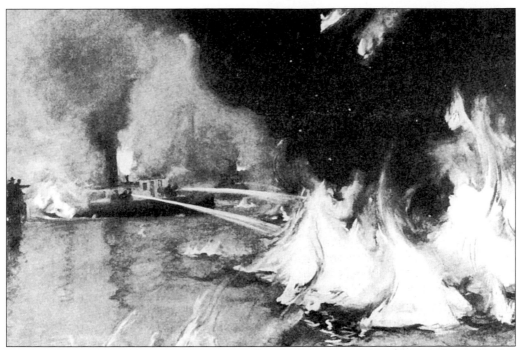

Among the most important tugs on the Chicago River were those operated by the fire department. Due to the disgusting array of pollution in the river, a mixture of industrial waste and run-off from streets reeking of horse droppings, the surface became combustible every summer.

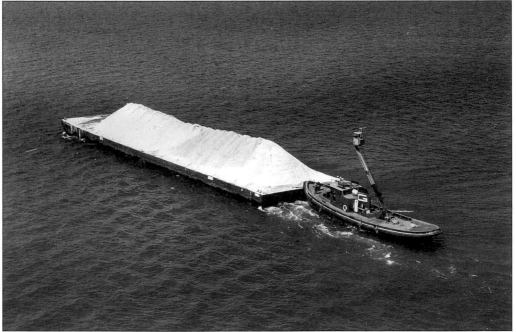

Long after most other shipping abandoned the Chicago River harbor, tugboats continued to utilize the waterway. Here a modern tugboat with an adjustable bridge pushes a load of gravel past the breakwater of the outer harbor.

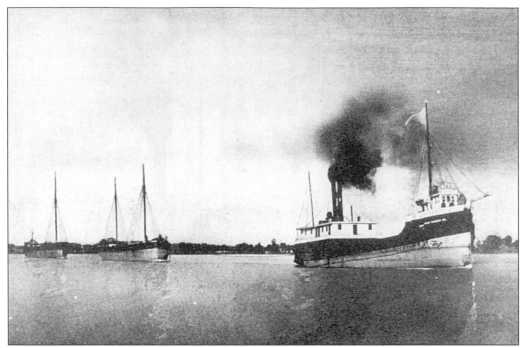

The movement away from sailing ships to steam vessels in the bulk cargo trade began with the use of steam barges to tow several schooners from port to port. The schooners were shorn of their topsails and functioned simply as barges.

A variation on the steam barges was the so-called "Rabbit." These first steam carriers had masts and sails to speed the ship in fair weather. "Rabbits" were adaptable, if small, bulk carriers with high bows and a raised wheelhouse aft. Pictured here is the *City of Mt. Clemens*, about 1910, carrying a cargo of salt.

A unique stage in the development of Great Lakes shipping was the era of the whalebacks, 1888–1896. The invention of Captain Alexander McDougal, the whalebacks were flat-bottomed, rounded top, steel ships that were remarkably steady sailors. In less than a decade, 43 of this type of ship were built, most for use on the Great Lakes. Their era was short lived, however, because of the need to develop large deck hatches to unload cargoes quickly.

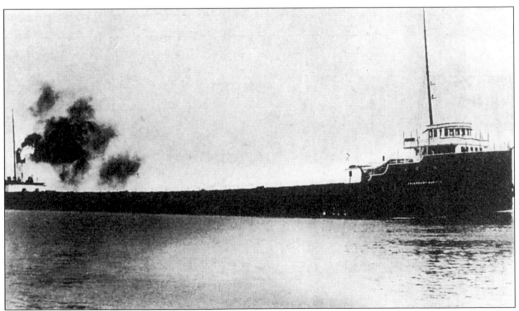

In 1906 the first modern Great Lakes freighter was born, the *J. Pierpont Morgan*. Built in South Chicago as an iron ore carrier, the *Morgan* was 605 feet in length. For the next 35 years, the "six hundred footers" formed the backbone of the lake marine.

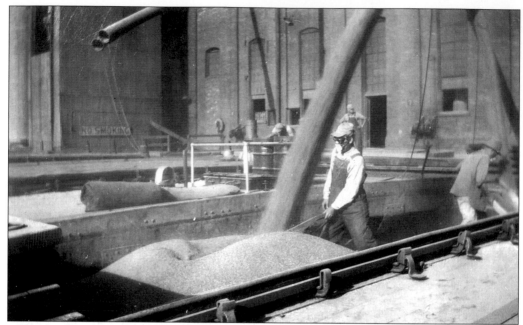

Life and labor aboard a "six hundred footer" was a mixture of managing the cargo, maintaining the ship, and coping with the elements. Here in 1948, the crew of the *Moloney* direct a spout pouring wheat into the ship's hold at Superior, Wisconsin.

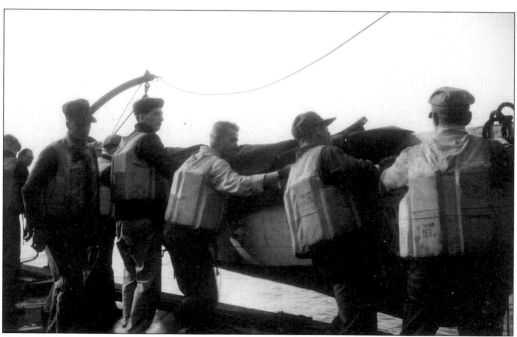

A boat drill was a standard procedure on each voyage. The great steel ore boats represented a sizable capital investment, and the large corporations, such as U.S. Steel or Republic Steel, encouraged safety to reduce insurance costs.

The first mate of the *L.C. Hanna* watches the giant bulk carrier slide into the Sault Ste. Marie lock. The locks were a vital choke-point of Great Lakes navigation. All ore freighters bound for the steel mills of South Chicago and northwest Indiana had to pass through the locks.

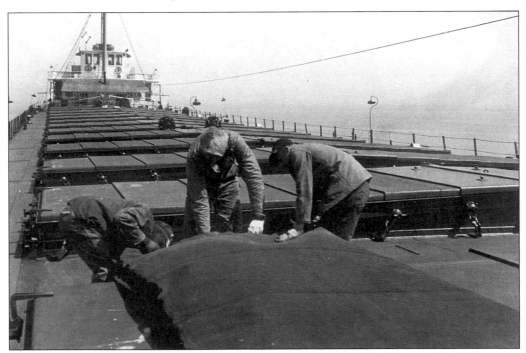

In fair weather, the crew of an ore carrier prepared for the storms that could strike at any moment. Deck duties included regularly checking the hatch covers and airing the tarps, as the men are doing in this July 1947 photograph.

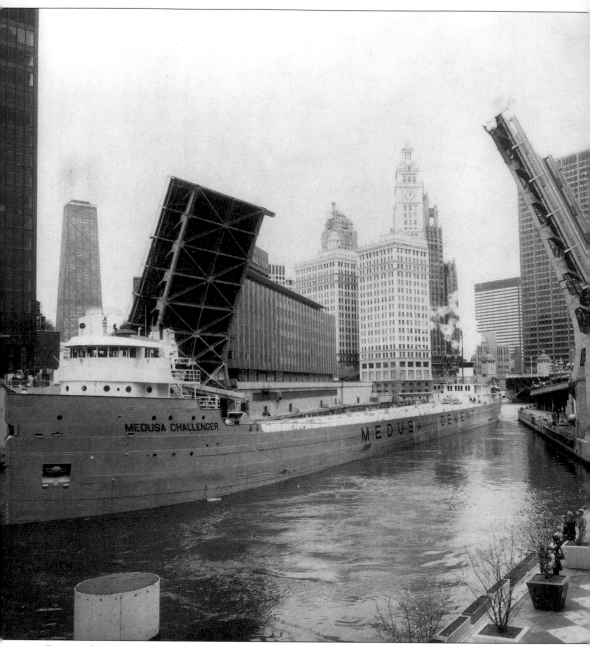

During the first two decades of the 20th century, most of Chicago's lake commerce shifted to the Calumet River at South Chicago. By the late 1960s, the arrival in the Chicago River of the *Medusa Challenger*, a 552-foot-long freighter, which carried cement powder up to Goose Island on the North Branch of the river, was an occasion for pedestrians to watch in awe, and motorists to complain of the traffic jams. (Courtesy of the Chicago Historical Society.)

Four

DEATH ON THE WATER

CHICAGO SHIPWRECKS

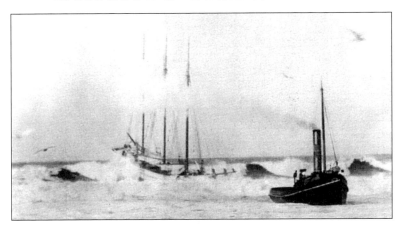

Shipwrecks are a part of any maritime history. Water is neither our natural element nor is it a force that human technology can control, particularly when it is in a form as large, powerful, and unpredictable as Lake Michigan. "There is a quiet horror about the Great Lakes which grows as one revisits them," remarked British writer Rudyard Kipling. He was shocked to find that the inland sea "engulfs and wrecks and drives ashore like a fully accredited ocean—a hideous thing to find in the heart of a continent." Each of the lakes have their historic navigation hazards, treacherous passages like Death's Door at the entrance to Green Bay, or dangerous shoals like Waugoshance at the far north end of Lake Michigan. The dangers of Chicago's waters, where more people have lost their lives than anywhere else on the Great Lakes, are twofold. Chicago's position near the far southern end of the lake leaves it exposed to the full fury of northern gale waters that have been driven the full 300 miles of the lake. Off Chicago, ships have little leeway with which to run before a powerful storm. Compounding this danger is the large volume of shipping that has historically converged on the city, creating the potential for a disastrous collision.

On bright sunny days the deadly nature of the lake seems deceptively remote. It was the last thing that was on the minds of the 62 chattering people who clambered aboard the excursion steamer *Favorite* on July 28, 1927. The double-deck vessels had long made the run from Lincoln Park to Navy Pier in perfect safety. But on that day a sudden thunderstorm forced the little ship broadside to the waves and in a horrifying instant capsized it. Lifeguards from Lincoln Park (including a teenage Johnny Weissmuller) and yachtsmen rushed to the site. But there was no rescue for 26 women and children and one man, most of whom had been trapped on the lower deck when the *Favorite* pitched on her side. In 1894 the little two-masted schooner the *Myrtle* was sunk with all hands within sight of hundreds of Chicagoans. Heavy seas made it impossible for rescue boats to reach her.

Chicago shipwrecks are stories of human folly, unrelenting misfortune, and at times the overwhelming power of a natural force both beautiful and terrible. It is well to remember that just a few feet off the city's crowded beaches lies a wilderness vast and deadly.

In the 1883 photo above, a tugboat tries to pull the Edward Hines Lumber Company schooner *Carrier* over a sand bar. A grounded vessel would be in danger of being broken up by the white-capped breakers. The most frequent of the thousands of Lake Michigan shipwrecks was for sailing ships to be blown aground on a lee shore.

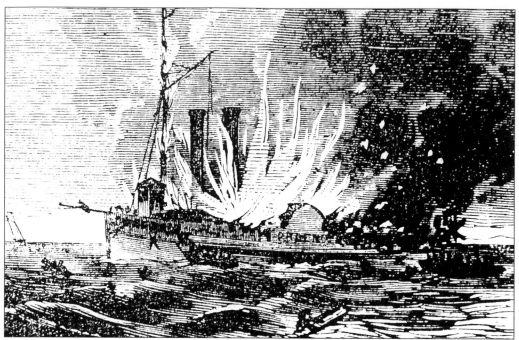

In 1847 steamboat *Phoenix* caught fire and sank near Sheboygan, taking more two hundred Norwegian immigrants to a watery grave. A similar steamboat disaster occurred in 1868 off Waukegan, when a stiff April breeze fanned a few carelessly handled embers into a blaze that consumed the *Seabird.* The fire destroyed the ship's lifeboats before most of the hundred or so sleeping passengers were aware of the disaster. Most died on the burning boat or in the icy waters of the lake.

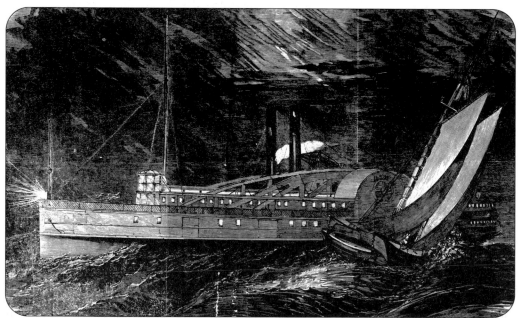

The collision between the passenger steamer *Lady Elgin* and the lumber schooner *Augusta* on September 8, 1860, was one of the worst disasters in Chicago history.

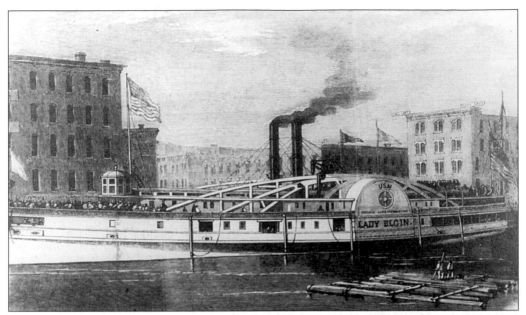

The *Lady Elgin* was known as the "Queen of the Lakes" because of her speed, reliability, and gracious appointments. For nine years she sailed the lakes in safety, usually operating out of Chicago. In September 1860 she was chartered for an excursion cruise from Milwaukee to Chicago as a way to raise funds for the Union Guards, an Irish-American militia company.

The helmsmen of both the *Lady Elgin* and the schooner *Augusta* failed to adjust their course enough to avoid the accident, in part due to heavy seas that reduced each vessel's maneuverability. After the ships struck, they drifted apart. The crew of *Augusta* thought they had done little damage to the larger steamship and tried to nurse their damaged ship into Chicago. As it turned out, they were only slightly damaged while the *Lady Elgin* had been stove in below the waterline.

Captain Jack Wilson of the *Lady Elgin* turned the rapidly sinking steamer toward the Illinois shore. He was a veteran mariner who hesitated to embark that night due to the prospect of a storm. He yielded his better judgement to pressure from passengers anxious to get home.

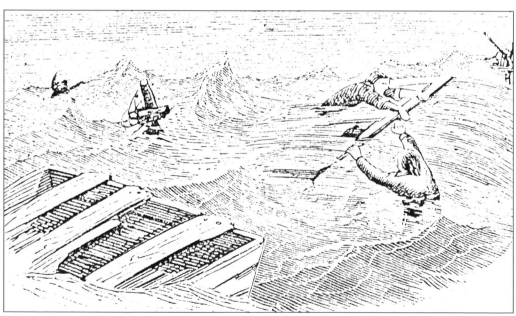

Between 350 and 380 passengers died when the *Lady Elgin* sunk several miles from shore. The panicked passengers tried to save themselves by clinging to pieces of the wreckage. The lifeboats had been swept away only partially full, and the life preservers were stored in the flooded hold.

The storm drove the survivors toward the Evanston shore. As they neared the land, breakers claimed many lives, dashing them against rocks amid heavy surf, just a few feet from safety. Captain Wilson died there. After bringing several passengers through the surf, he was smashed against a rock. Edward Spencer, a Northwestern University student, saved several people by swimming out into the surf.

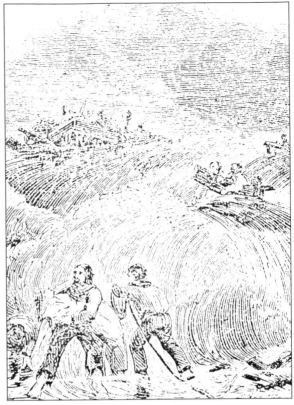

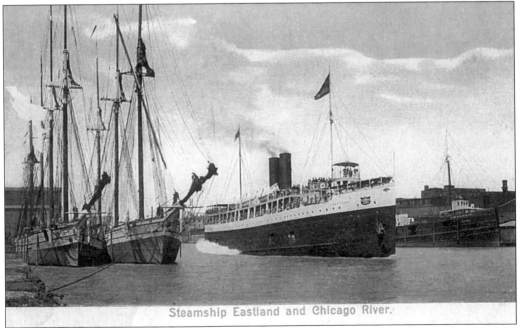

Steamship Eastland and Chicago River.

Pictured is the steamer *Eastland*, Chicago's most tragic ship. On July 24, 1915, the ship was boarded by 2,500 happy excursionists from the Western Electric Company. They were bound for Michigan City, Indiana, and a day of music and picnicking.

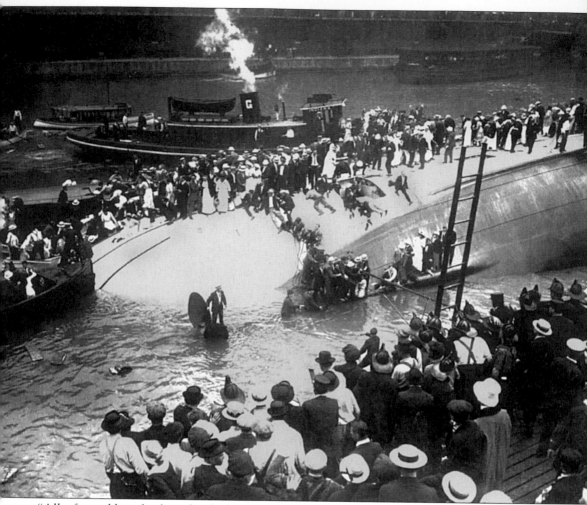

"All of a sudden the boat lurched....we heard loud crashing from below decks, and people started screaming," recalled a survivor of the *Eastland*. The improperly ballasted ship pitched on its side as it prepared to leave its Chicago River berth. (This image is contributed by Thomas Eckhardt in honor of the photographer, Fred Eckhardt. Courtesy of the Nelson Collection, Chicago Maritime Society [CMS].)

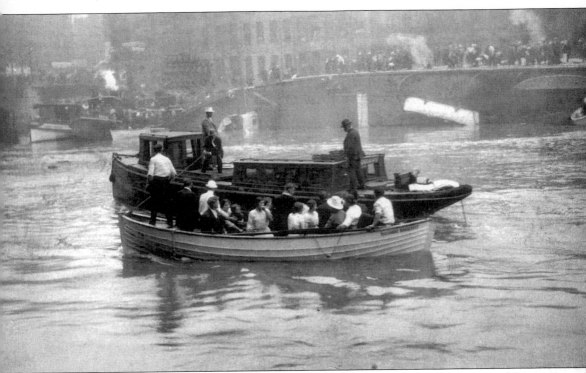

Jack Billow, an alert deckhand on the steamer *Theodore Roosevelt*, immediately put a lifeboat (pictured above) into the water. Hundreds of people were "screaming and crying, waving their arms...we rowed to the capsized ship where we helped people from the water and saw them safely to shore." Later Billow and other bystanders donned life jackets and tried to form a human chain in the water to pass people to safety. (Courtesy of the Nelson Collection, CMS.)

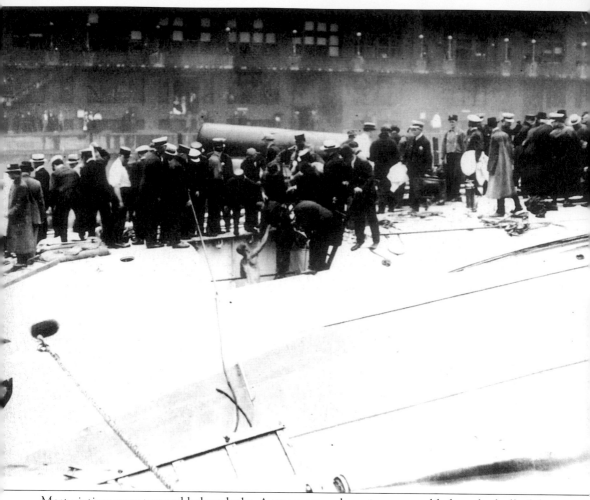

Most victims were trapped below decks. As rescuers and survivors scrambled on the hull of the overturned ship, the grim work of trying to recover the bodies began. (Courtesy of the Nelson Collection, CMS.)

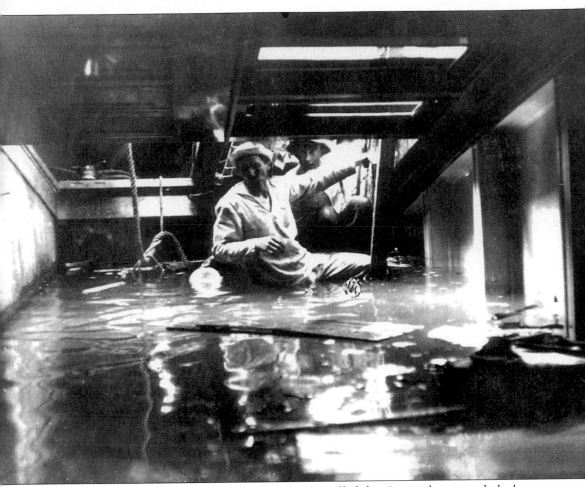

The scene inside the hull was ghastly. A rescuer later recalled that "picnic hampers, derby hats, and vacuum bottles bobbed alongside the bodies." (Courtesy of the Nelson Collection, CMS.)

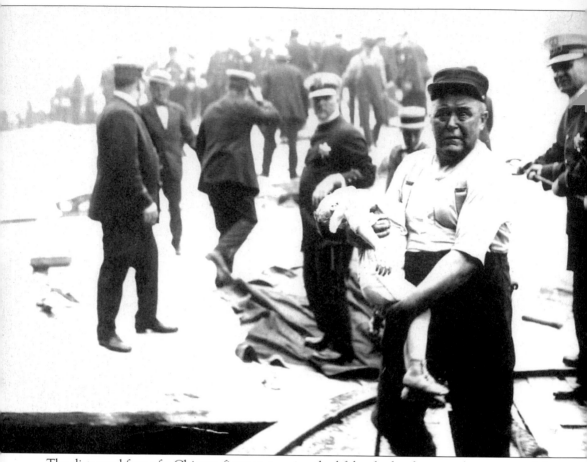

The distressed face of a Chicago fireman carrying the lifeless body of a young boy expressed the shock of the entire city to its greatest tragedy. (Courtesy of the Nelson Collection, CMS.)

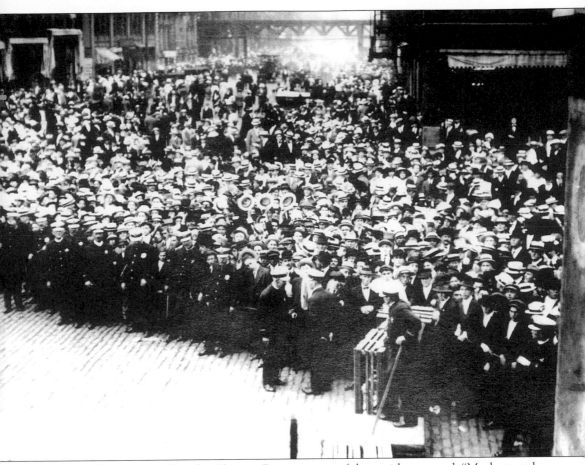

Thousands of people rushed to the Chicago River as news of the accident spread. "Mothers and fathers ranged the shore, screaming the names of their children," one witness later recalled. (Courtesy of the Nelson Collection, CMS.)

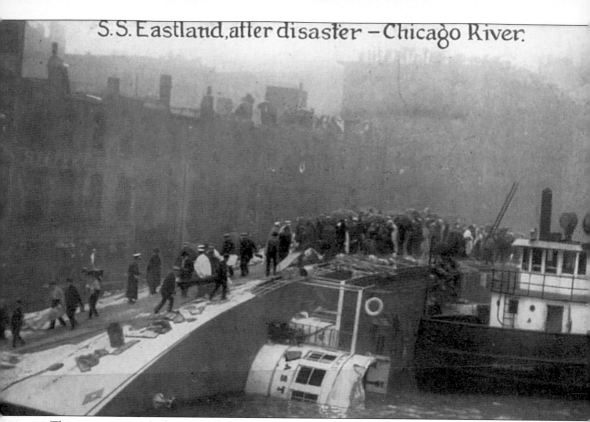

S. S. Eastland, after disaster — Chicago River.

This grim postcard illustrates the heartbreaking job of removing the bodies from the wrecked ship.

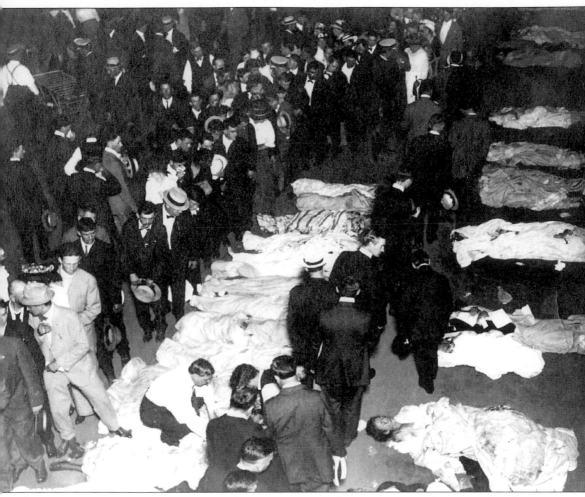

Improvised morgues were set up in the warehouses and armories near the river. For days afterward, long lines of grief-stricken Chicagoans made their way through these buildings trying to identify lost loved ones. Many who boarded the *Eastland* were never found, although officials put the loss total at more than 800 dead. (Courtesy of the Nelson Collection, CMS.)

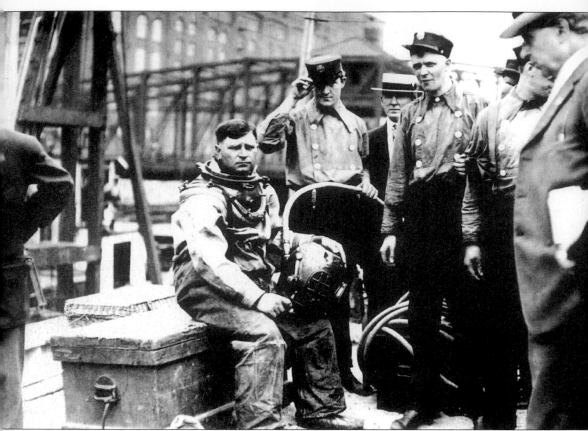

The *Eastland* was the greatest disaster in the history of Great Lakes shipping. Divers were sent into the murky waters of the Chicago River to try and recover all of the victims. The hard hat dive suit is part of the collection of the Chicago Maritime Society. (Courtesy of the Nelson Collection, CMS.)

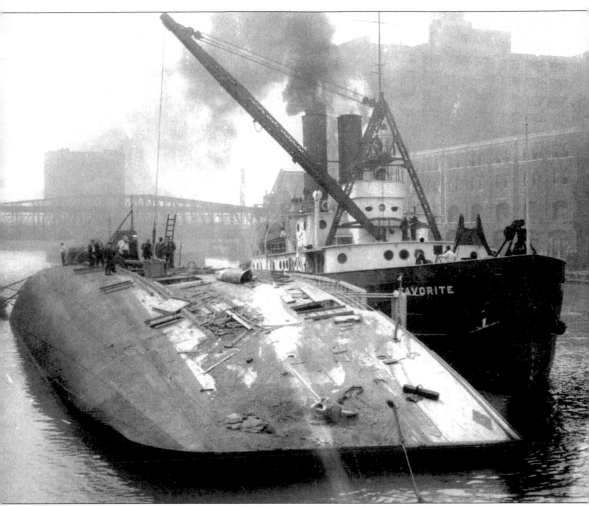

Shortly after the tragedy, salvage work began on the *Eastland*. As World War I raged, there was a shipping shortage. (Courtesy of the Nelson Collection, CMS.)

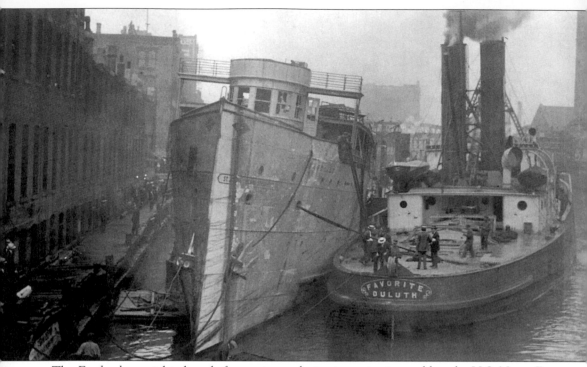

The *Eastland* was righted, and after an inconclusive investigation, sold to the U.S. Navy. From 1918 to 1948, she served as the *USS Wilmette* with no repeat of the tragic events of 1915. (Courtesy of the Nelson Collection, CMS.)

Five

A BEACON ON THE SHORE

LIGHTHOUSES AND

LIFESAVING STATIONS OF CHICAGO

A lighthouse, more than any other terrestrial structure, symbolizes a community's relationship with the vast blue, alien world of water. With ships and pleasure boats people venture out into its vast expanse in quest of profit and pleasure, but always the need to return to land is stronger then the lure of the water. The lighthouses of the Illinois shore of Lake Michigan are enduring reminders of the dangers inherent in lake navigation.

Historically there were six lighthouses in the Chicago area. The oldest was built in 1832 near the site of the Michigan Avenue bridge. The most recent is the current Chicago Harbor Lighthouse, built in 1917. Each of these are examples of how the U.S. Government played a vital role in developing the blue-water frontier of the Great Lakes for use by people and businesses. While federal army posts were critical to settling the western frontier, it was the white, conical tower of the lighthouse that helped to turn untamed inland seas into inland waterways.

In addition to lighthouses, the government also operated life-saving stations along the shore of Lake Michigan. The United States Life-Saving Service dated from 1871, and once operated stations at Evanston, Chicago, Jackson Park, and South Chicago. The Life-Saving Service compiled an impressive record during its brief history. During the 38 years of its operation, the Evanston station, for example, rescued all of the people in distress within its district. The Chicago Harbor station serviced 359 ships during its tenure. In 1915 the Life-Saving Service was brought under the control of the U.S. Coast Guard. The Lighthouse Service also became part of the Coast Guard, but not until 1939. Beginning in the 1930s the lighthouses of the Chicago area were gradually automated, making it unnecessary for light keepers to reside in their unusual, if romantic, buildings.

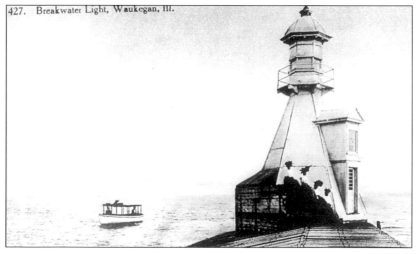

Pictured is the old Waukegan breakwater lighthouse.

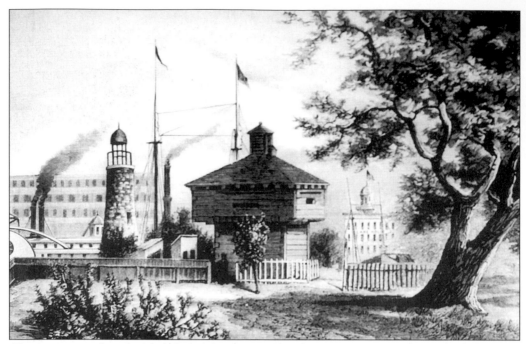

Chicago received its first lighthouse in 1832. Built adjacent to Fort Dearborn, the light stood 50 feet high.

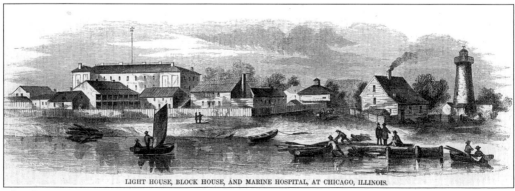

LIGHT HOUSE, BLOCK HOUSE, AND MARINE HOSPITAL, AT CHICAGO, ILLINOIS.

The first attempt to erect the original Chicago lighthouse ended in failure when the nearly completed tower collapsed because the foundation had been laid in quicksand. This illustration from 1856 shows the tower just before it was replaced.

In 1859 a new lighthouse was built for the Chicago harbor. It was a skeletal iron tower built at the end of the harbor pier. Although higher than the old light tower, even this new light was often obscured by smoke from factories and steamships. This tower is still in use today at Rawley Point in Wisconsin.

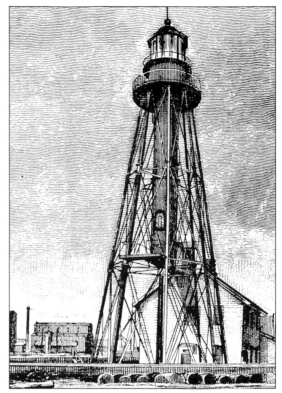

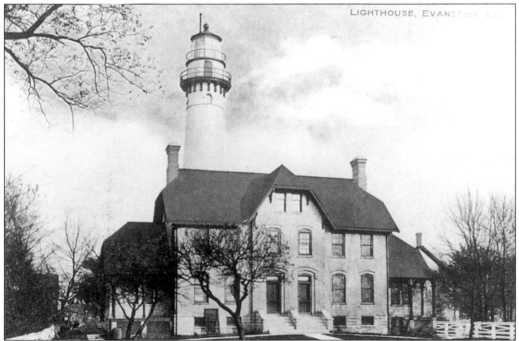

The Grosse Point Lighthouse was constructed in 1871. The Lighthouse Board chose the Evanston location because of the dangerous shoals nearby, and because Grosse Point jutted prominently out from the Illinois shore.

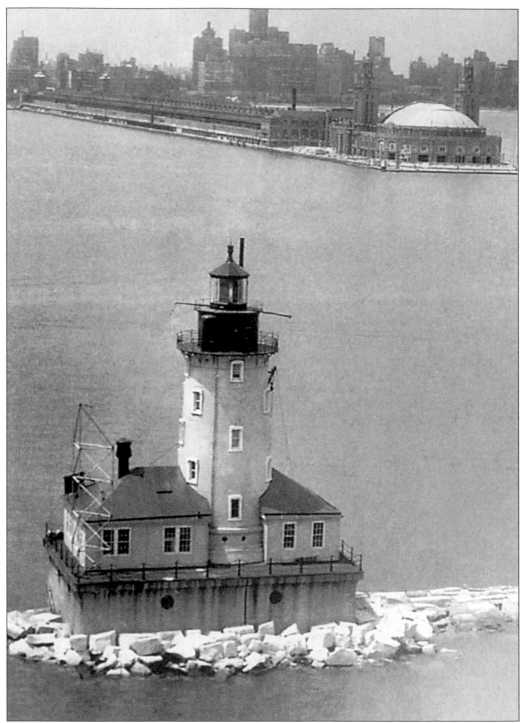

The current Chicago harbor light was originally constructed in 1893 at the end of the harbor pier. Then in 1910 the U.S. Army Corps of Engineers began major improvements on the entire Chicago harbor. As part of this effort, the light was moved in 1917 to a crib at the end of the outer harbor breakwater.

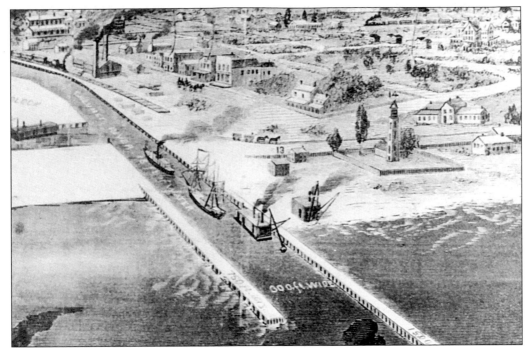

The original South Chicago Lighthouse was built in 1853 of stone quarried in Blue Island, Illinois. To the disgust of local boosters, the government discontinued the light (because of limited traffic) shortly after it was built.

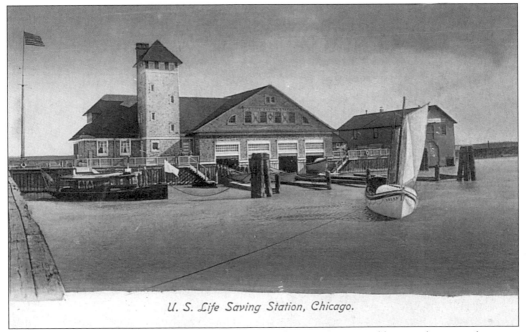

U. S. Life Saving Station, Chicago.

The first Chicago life-saving station was established in 1875. Pictured here is the second station (1903–1933), which was located on the breakwater at the mouth of the Chicago River. The third station was completed in 1936 and is used today for the Chicago Police Marine Division.

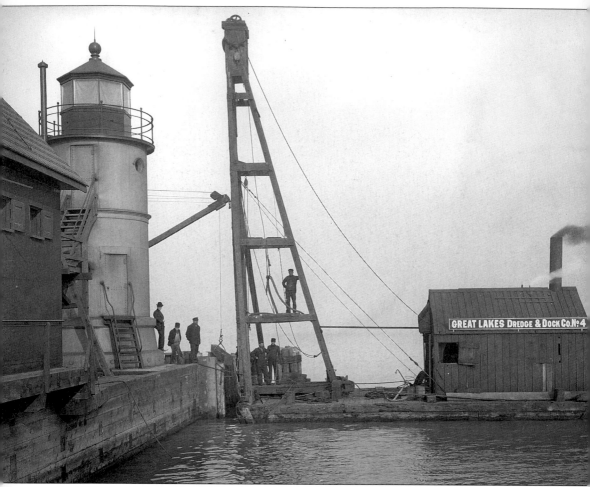

By 1870 the Calumet River developed into a busy harbor, and the federal Lighthouse Board committed to re-establishing the South Chicago light. The current South Chicago Lighthouse was built in 1923 at the end of a long breakwater.

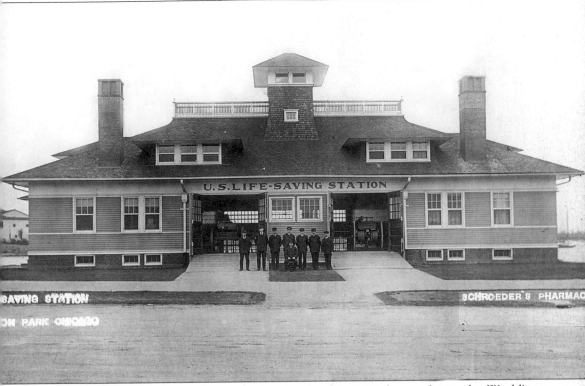

The Jackson Harbor Life-Saving Station was constructed in 1893 for use during the World's Fair. Due to changes in that recreational harbor, a new station had to be built in 1906. It remains in use by the Chicago Park District.

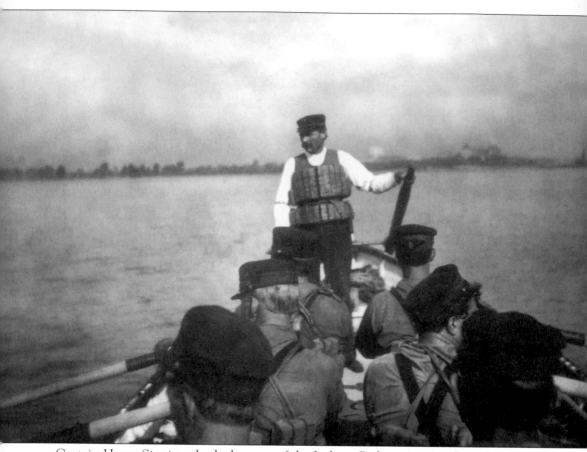

Captain Henry Sinnigen leads the crew of the Jackson Park station in a boat drill. During its 21 years of existence, the station's men saved 354 lives and recovered 96 percent of the vessels and cargoes at risk in its area.

Six

CHICAGO'S NAVY

WARSHIPS ON LAKE MICHIGAN

Chicago has never been the scene of hostile naval action. Unlike Lake Erie or Lake Ontario, Lake Michigan has never been the seat of war. Yet as the greatest port on the Inland Seas, Chicago has frequently been host of naval vessels. Gunboats, submarines, and aircraft carriers have all played a role in Chicago's maritime history.

Some of the warships that have become part of Chicago maritime lore had unlikely foreign origins. The U-505, the World War II German submarine at the Museum of Science and Industry, is perhaps the best known and most widely visited warship in Chicago history. Less well-known is the UC-97, a German submarine from World War I that was brought to Chicago as part of a war bond drive in 1919. This special mine-laying submarine was trophy of war sent to the Great Lakes after the surrender of the Imperial German Navy. After fulfilling her public relations mission the Illinois Naval Reserve used her for target practice. Guns from the USS Wilmette and the USS Hawk pumped 18 rounds into the UC-97. She sank somewhere off the North Shore, and in recent years has been the subject of numerous efforts to locate by underwater explorers.

The naval vessels with the longest history of association with Chicago were those associated with training sailors, which was first done by the Illinois Naval Militia. From 1901 until 1909 Chicago was home port to the USS Dorthea, a yacht converted to use as a gunboat. The vessel, however, was too small to accommodate the hundreds of naval militia tars, and was replaced by a genuine warship, the USS Nashville, the ship that fired the first shots in the Spanish-American War. From 1919 to 1945 the gunboat USS Wilmette served as Chicago's training ship. During World War II, Chicago also served as the base for the USS Wolverine and the USS Sable, aircraft carriers that trained naval aviators in the art of landing their planes on ships.

Today, only the U-505 remains as a reminder of naval history. While the Great Lakes Naval Training Station near Waukegan continues to grow, the only United States naval vessel seen in Chicago is single escort vessel sent for a week each summer as part of the Navy's annual Great Lakes recruiting cruise.

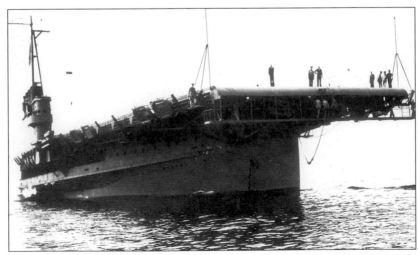

The USS Wolverine was the first and likely the last aircraft carrier to dock in Chicago. (Courtesy of the National Archives.)

The paddlewheel gunboat *USS Michigan* (1843–1949) was for a long time the only United States warship on the Great Lakes. She was a frequent visitor to Chicago. In an act of criminal ingratitude, the historic ship was broken up for scrap in 1949.

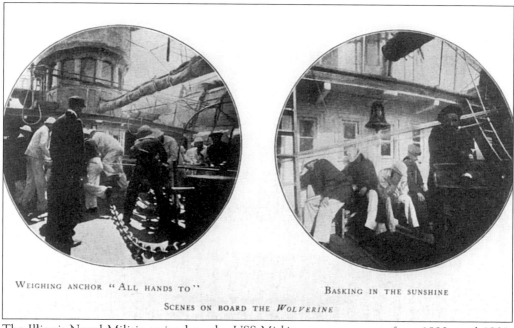

WEIGHING ANCHOR " ALL HANDS TO" BASKING IN THE SUNSHINE

SCENES ON BOARD THE *WOLVERINE*

The Illinois Naval Militia trained on the *USS Michigan* every summer from 1890 until 1901. The unit was the result of the interest in naval affairs sparked by the late 19th century age of imperialism.

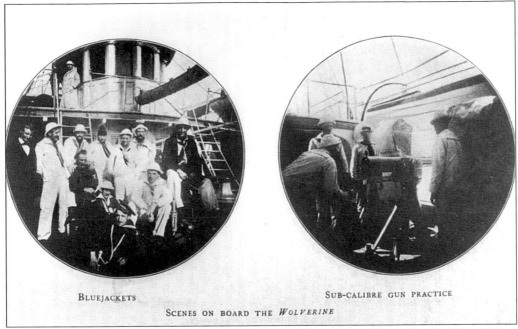

BLUEJACKETS SUB-CALIBRE GUN PRACTICE

SCENES ON BOARD THE *WOLVERINE*

The citizen sailors of the Naval Militia were known in the press as "bluejackets" or "tars." Here the tars are put through a gun practice. After 1905 the *USS Michigan* was renamed *USS Wolverine* (not to be confused with the later aircraft carrier) to make way for a modern battleship.

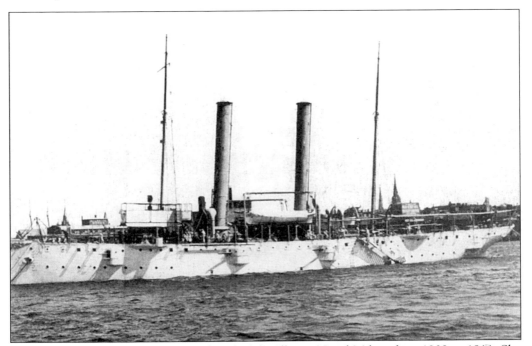

The *USS Nashville* was the training vessel of the Illinois Naval Militia from 1909 to 1911. She was later replaced (in 1918) by the *USS Wilmette*, which was the infamous *Eastland*, raised and refitted for military use.

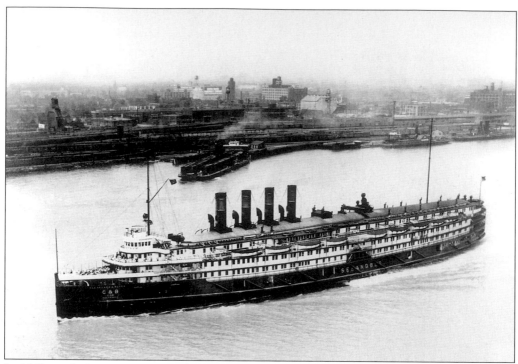

In 1942, with the nation engaged in a naval and island war against Japan, there was an acute need for pilots trained to land on aircraft carriers. Commander Richard F. Whitehead argued that the secure waters of the Great Lakes was the best place for training. The paddlewheel steamer *Seeandbee* was hastily converted into an aircraft carrier.

Following the successful conversion of the *Seeandbee* to the USS *Wolverine*, a second Great Lakes paddlewheel steamer, the *Greater Buffalo*, was converted in 1943 to the aircraft carrier USS *Sable*.

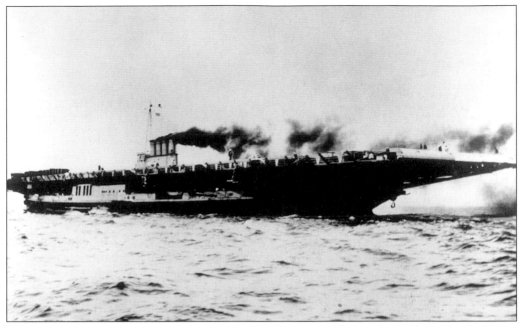

The aircraft carriers were an impressive sight to Chicagoans. Although the *Seeandbee* had been one of the largest paddlewheel steamers in the world, the *USS Wolverine* was several hundred feet smaller than the large carriers of the Seventh Fleet such as the *USS Enterprise* and the *USS Yorktown*.

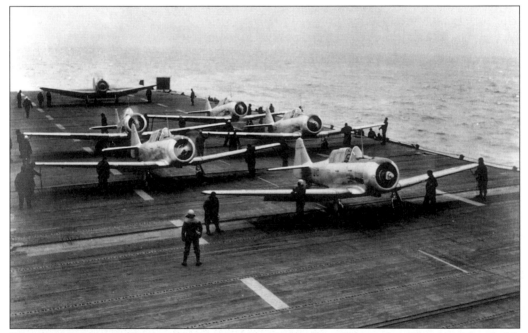

Pilots seeking to qualify for naval operations would take off from the Glenview Naval Air Station field, fly over Evanston, and rendezvous with the carriers for their first landing. After several planes had landed, they had to be turned around for take-off. There were no hanger decks of the *Wolverine* or *Sable*.

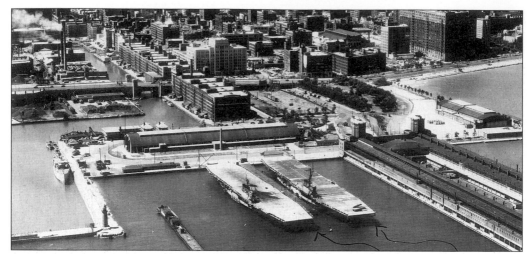

The *Wolverine* on the right and the *Sable* on the left, were regularly docked at Navy Pier. To the far left, inside the breakwater, can be seen the *Wilmette*.

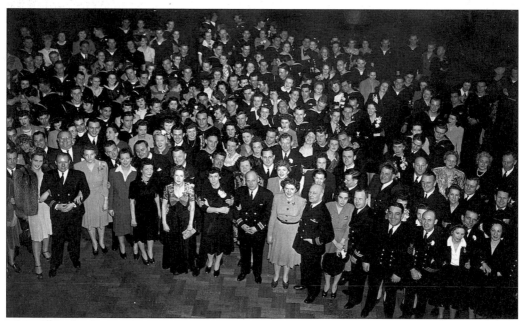

The officers and crew of Chicago's aircraft carriers enjoy a gala evening. The ships were engaged in fielding planes seven days a week, although for safety's sake, no landings took place after dark.

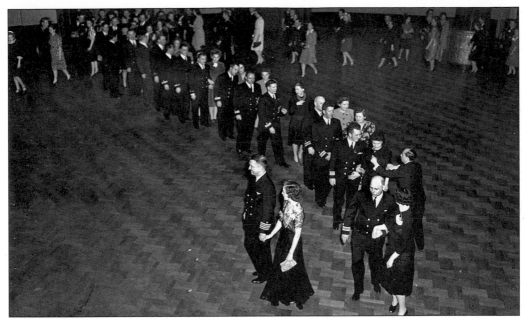

Chicago was known as a great liberty port during World War II. Scores of nightclubs, hotels, and restaurants gave sailors and pilots plenty to do when they were favored with passes. The USO sponsored many social activities at service men's centers and at downtown hotels.

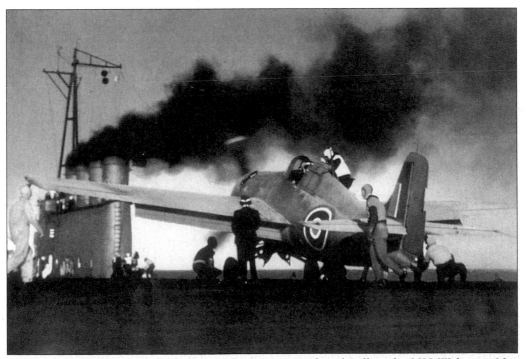

A Grumman Wildcat with Canadian markings prepares for takeoff on the USS *Wolverine*. Not only were the freshwater flattops shorter than the fleet carriers, the decks were only 26 feet above the water. Upon launching, planes normally dipped as they cleared the ship, many inexperienced pilots dropped to wave top or worse, as they made their first takeoff on *Wolverine*.

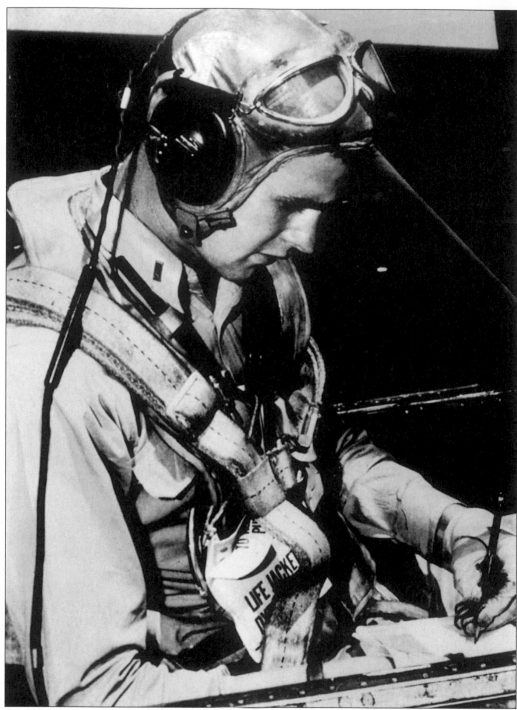

Nearly 18,000 pilots qualified as naval aviators on *Wolverine* and *Sable*. Among them was a future president of the United States, George Bush. He made eight dangerous winter landings and takeoffs on the freshwater flattops. "I remember those Great Lake flights very well in the open cockpit that winter," he later recalled, "Coldest I ever was in my life." He went on to serve heroically in the Pacific as a torpedo plane pilot.

Chicago's aircraft carriers also trained the flight deck crews. Before the two ships were decommissioned and sold for scrap in 1948, they had successfully trained 22,000 carrier-support personnel.

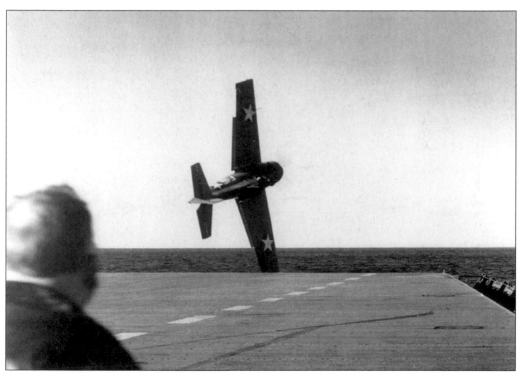

The risky business of landing a plane on the pitching deck of a moving ship inevitably led to accidents. Twenty-one young pilots lost their lives trying to qualify for carrier duty. More than 250 planes were lost in Lake Michigan. A half-century after the war, the cold dark waters of the lake are one of the best sources for vintage naval war planes.

Boat House and Basin,

U. S. Naval Training Station, Great Lakes, Ill.

The Great Lakes Naval Training Station was established in 1911. It trained thousands of sailors for both world wars, and the Korean and Vietnam Wars. Today it is one of the largest naval training centers in the world.

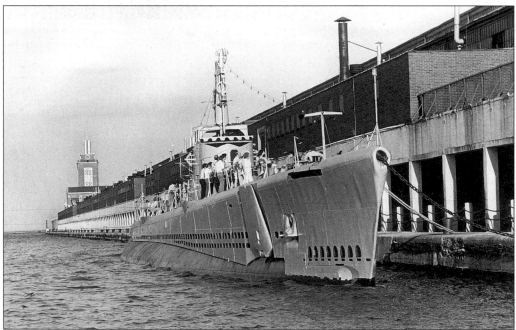

The USS *Silversides* was one of the most distinguished members of the U.S. Navy's World War II submarine fleet. During the 1970s, Chicago naval enthusiasts brought the decommissioned ship to the city and painstakingly restored the submarine to full working condition. For several years it was docked at or near Navy Pier. Bureaucratic bungling by the City of Chicago and poor leadership by the *Silversides* board led to the ship being removed to Muskegon, Michigan, where it is today.

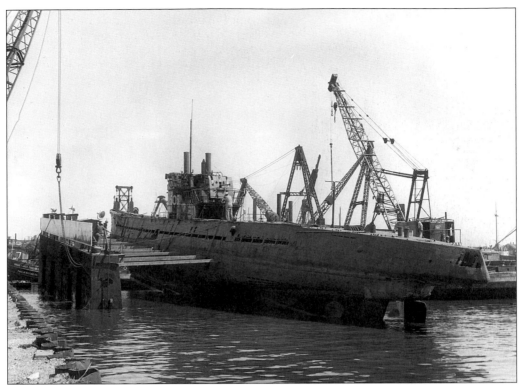

Ironically, the naval ship with the most long-lasting relationship with Chicago is not even an American warship. The U-505, a Type-IXc U-boat, was captured in 1944 on the high seas by a United States naval taskforce.

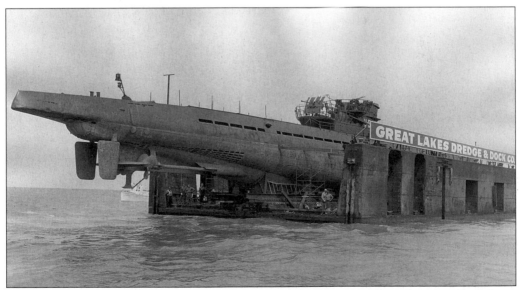

The U-505 was commissioned in August 1941, and during its career sunk eight allied ships, three of them American flag vessels. Even in the hazardous German submarine service, she was known as an unlucky ship. That bad luck continued when an attempt by her crew to scuttle the ship failed, and an American boarding party was able to seize her as a prize of war.

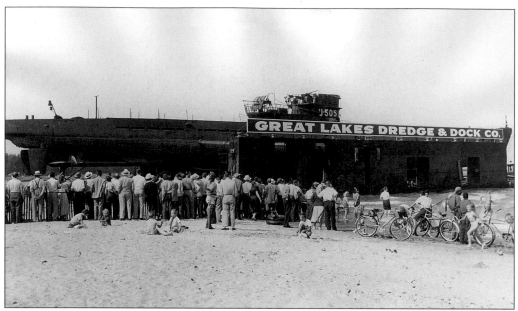

In 1954 Chicagoans raised $250,000 to save the ship from being destroyed by gunnery practice. She was towed to the city, put into a floating dry dock, and brought to the beach across from the Museum of Science and Industry.

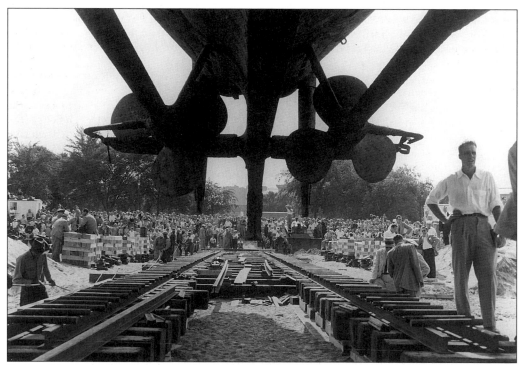

Railroad tracks were laid on the beach and across Lake Shore Drive to bring the submarine to the museum. Dedicated as a memorial to those who served and died in naval action, the *U-505* was also made a National Historic Landmark in 1989. Since coming to Chicago, the U-boat has been visited by more than 23 million people.

Seven

A LAKEFRONT FOR THE PEOPLE

"The lakefront by right belongs to the people," wrote Daniel Burnham. "It affords their one great unobstructed view, stretching away to the horizon, where water and clouds seem to meet." Thanks in part to Burnham's plan for Chicago in 1909, the beaches and parks of the lakefront have been Chicago's front yard for more than a century. Today these park lands are most Chicagoans' only link to the city's maritime character.

The Burnham Plan was not fully realized. The numerous off-shore islands with their playgrounds, beaches, and pathways, remain but a dream. It took the national tragedy of the Great Depression to secure the federal funding that made it possible to partially implement Burnham's plans for the north and south lakefronts. Without those massive, truly big-shouldered, construction projects during the 1930s, large portions of the lakefront would be in private hands.

Even before the Burnham Plan, Chicagoans had demonstrated their concern for the shoreline lands. Thanks to the foresight of the city fathers, the town's lakefront was ruled to be "Public Ground—A Common to Remain Forever Open and Free of any Buildings, or Other Obstruction whatever." Beginning in 1890, the catalogue mogul Aaron Montgomery Ward launched a lonely and expensive fight to keep the downtown lakefront free of buildings. He did not win every battle but he did prevail often enough that Grant Park developed as a vast formal park. During the 19th century, Chicagoans also reversed the flow of the Chicago River and built the water cribs. The former kept the filthy Chicago River from fouling the lakefront, while the latter secured clear lake water for the city's drinking water supply.

From the first soldiers at Fort Dearborn to the sun-worshippers of today, the beaches of Lake Michigan have been a magnet to Chicagoans. In the days before air conditioning, when too many residents lived in efficiency apartments, the lakefront was a place to cool off and bathe. During the colder months the beaches and parks were less intensely utilized than today. While these days joggers and bikers flock to the lake parks in all seasons, the beaches in winter still provide a slice of solitude impossible to find amid the skyscrapers. For the people of the city the lake will always be, as Willa Cather wrote, the promise of an "escape from dullness...The sun rose out of it, the day began there; it was like an open door that nobody could shut...You had only to look at the lake, and you knew you would soon be free."

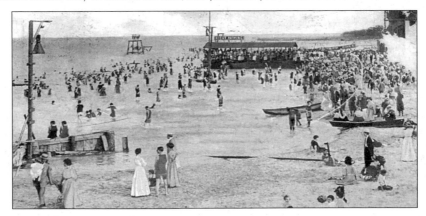

Pictured is Wilson Avenue Beach, as it appeared in 1915.

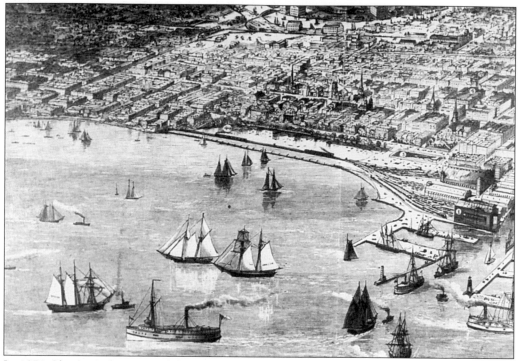

In 1871 Chicago's downtown lakefront was dominated by the Illinois Central Railroad, whose tracks formed a breakwater. Much of the rest of the shoreline was dominated by warehouses, lumberyards, or unkempt beaches.

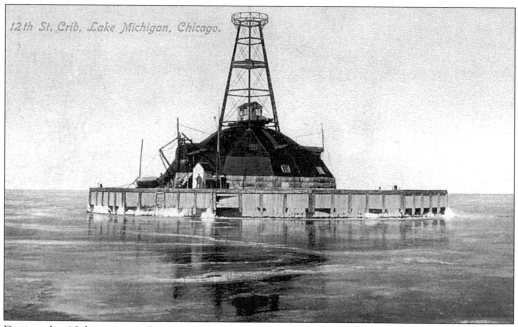

12th St. Crib, Lake Michigan, Chicago.

During the 19th century, the most important addition to the lakefront scene was the building (1864–1866) of the first of the water intake cribs 2 miles off Chicago Avenue.

During the winter of 1874-75, Lake Michigan was frozen for several miles from shore, and adventurous Chicagoans hiked over the ice to the crib.

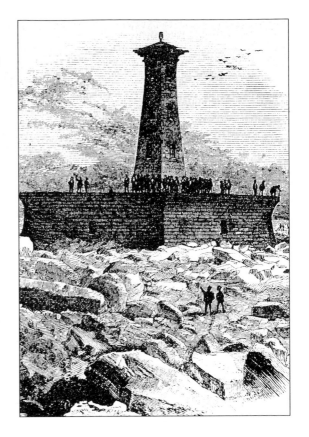

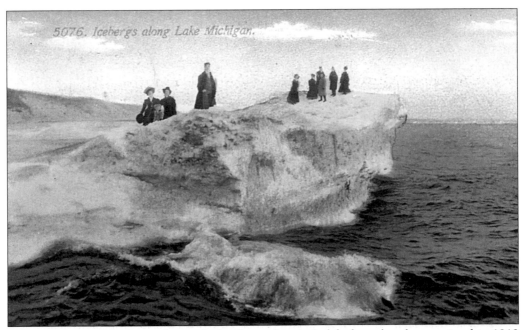

Lake storms would often pile ice high along the city's lakefront beaches, as in this 1912 postcard.

An important stimulus to developing the south lakefront was the 1893 World's Columbian Exposition held in Jackson Park.

Work began on building the White City in June 1891. The site was described as "a waste and desolate sand plain with a streak of marshy pools in the heart of it."

Pictured at right is lunchtime for two of the thousands of workers whose labor affected the magical transformation of the fairgrounds. These illustrations are from *Outing Magazine* (1892).

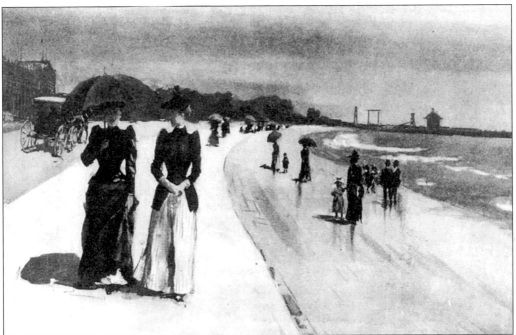

The World's Fair resulted in the graceful lakefront promenades that are still a feature of the south lakefront.

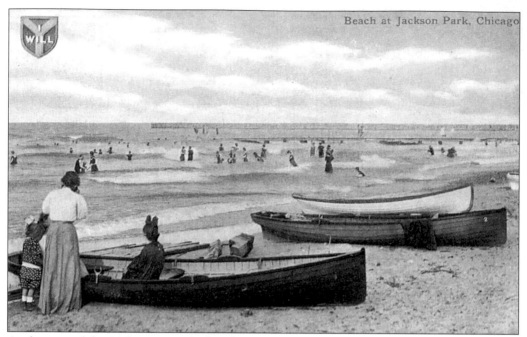

At the start of the 20th century, the beaches of Jackson Park were a popular summer refuge for most Southsiders.

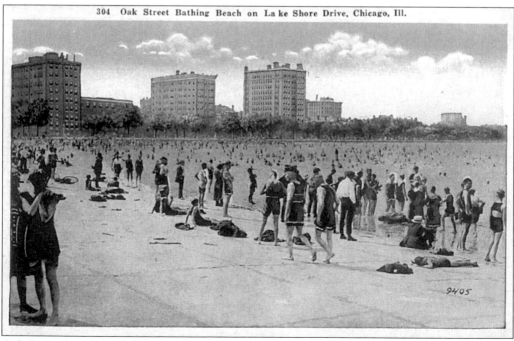

Oak Street Beach has been one of the city's favorite summer resorts for nearly a century, as this 1912 postcard attests. In 1962 the charm of the site was nearly destroyed by a proposed multi-level highway interchange.

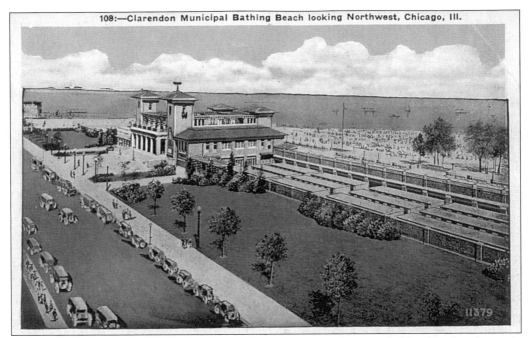

108:—Clarendon Municipal Bathing Beach looking Northwest, Chicago, Ill.

Before the 1930s most of the north lakefront was privately owned. Neighborhood people complained that beach behavior was rowdy and lewd. In 1912 the City of Chicago began the development of a municipal beach and bathhouse at Clarendon Street.

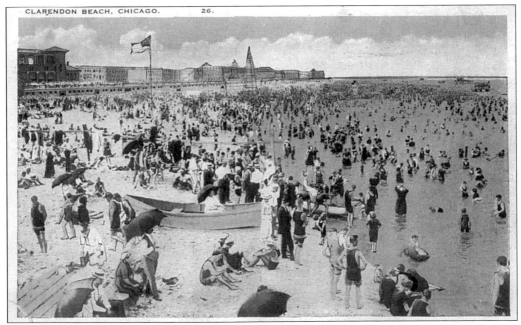

CLARENDON BEACH, CHICAGO. 26.

Opened in 1915, Clarendon Beach set strict standards for beach dress and behavior. Nonetheless, it quickly became one of the most popular summer spots in Chicago, crowding as many as ten thousand bathers on its 774 feet of beach.

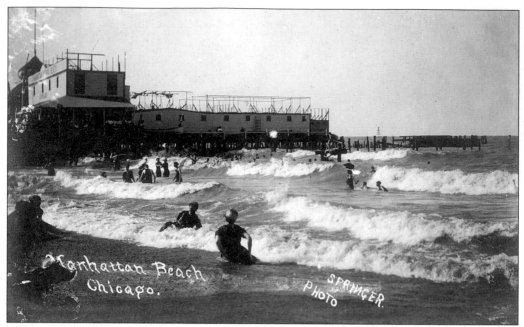

The private beaches of Chicago often featured pier structures that housed changing rooms and food service. Uptown beaches were particularly popular between 1900 and 1930, when that neighborhood was known as "Chicago's Atlantic City."

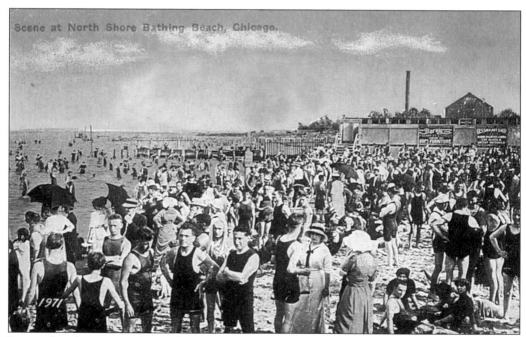

Private beaches required an admission charge and were fenced to keep out interlopers. The notion that beaches were the "common heritage of all the people" was voiced for the first time in 1909 by the city council.

A WINDY MORNING ON LAKE MICHIGAN,

In 1906 the shore of Lake Michigan was haphazardly developed.

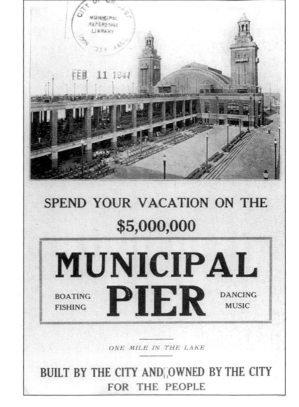

SPEND YOUR VACATION ON THE

$5,000,000

MUNICIPAL

BOATING FISHING **PIER** DANCING MUSIC

ONE MILE IN THE LAKE

BUILT BY THE CITY AND OWNED BY THE CITY

FOR THE PEOPLE

In 1915 Chicago completed a major portion of the Burnham Plan with the opening of Municipal Pier (later Navy Pier). It was designed to accommodate shipping, but its main purpose was recreation.

97

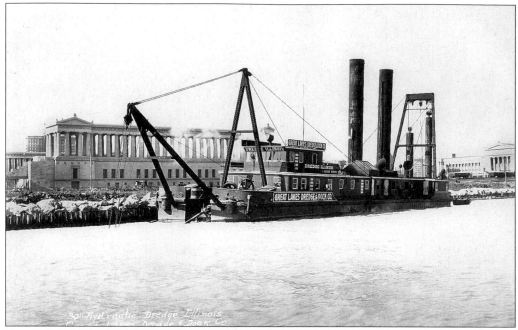

Major changes to the lakefront began in the 1920s, when the Field Museum and Soldier Field were constructed on the lakeshore near 12th Street.

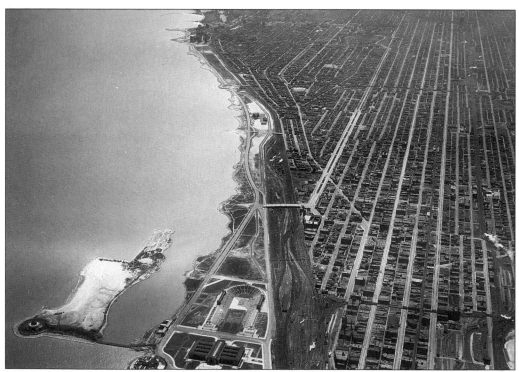

Daniel Burnham's plan for a series of islands along the Chicago shoreline was never realized, but Northerly Island, just east of Soldier Field, was constructed. This 1931 photograph shows the newly completed island.

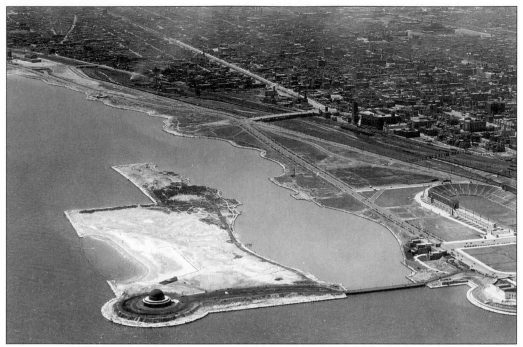

Northerly Island was still largely an unimproved landfill when it was proposed as the site of the 1933 Century of Progress World's Fair. Note the site was still a genuine island at the time with only a narrow causeway linking it to the mainland.

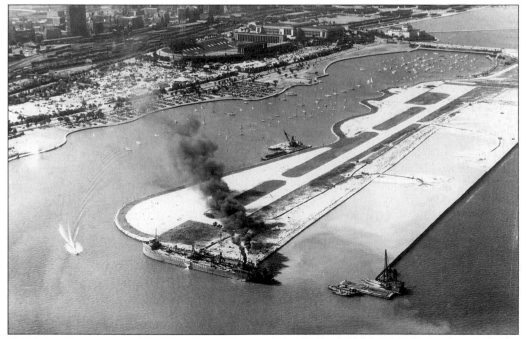

Following the success of the Century of Progress, the City of Chicago made the great mistake of converting much of Northerly Island to an airport. First proposed in 1935, work was begun on Meigs Field in 1947.

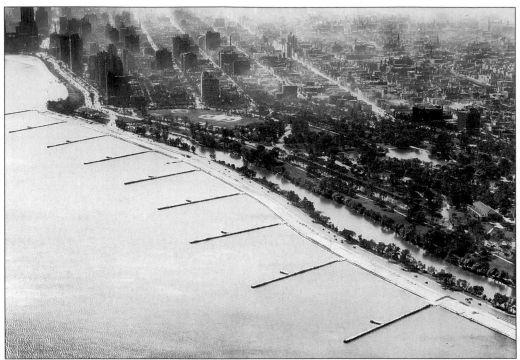

During the late 1920s, Lincoln Park underwent considerable changes. One of the least attractive of these was the construction of shore protection jetties.

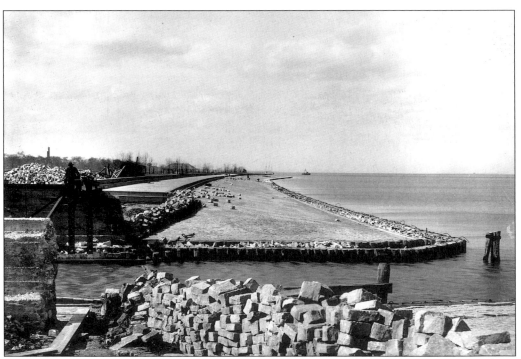

One of the forces giving momentum to the gradual expansion of Lincoln Park northward was the need to develop Lake Shore Drive as a major north-south automobile link.

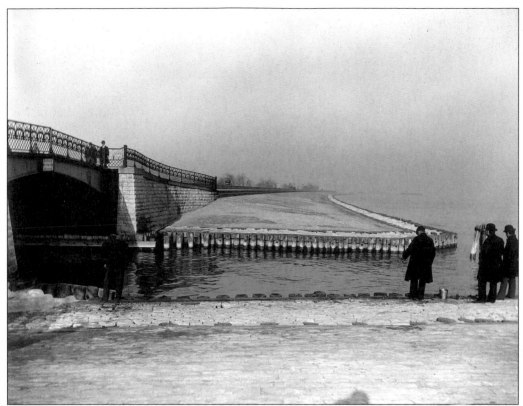

A bridge over the entrance to Diversey Harbor is completed.

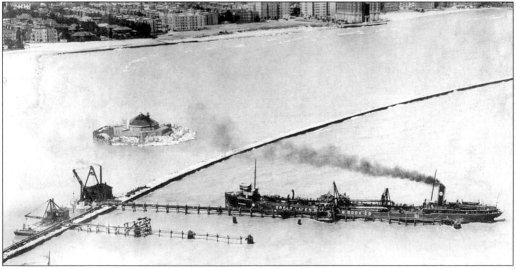

With the breakwater created, a Great Lakes Dock and Dredge ship prepares to unload fill that will be used to complete the landfill and render several miles of waterfront property landlocked.

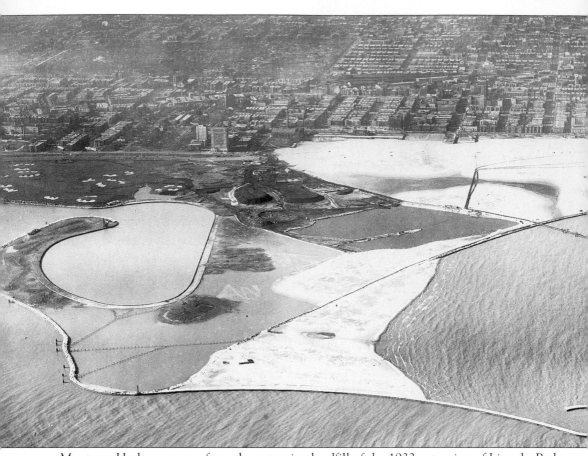

Montrose Harbor emerges from the extensive landfill of the 1932 extension of Lincoln Park.

Eight

A BOAT ON THE LAKE

YACHTING AND

RECREATIONAL BOATING

"It is very lamentable," a sports writer noted in 1900, "that Chicago should, when her wealth and population is considered, be so far behind other lake cities in yachting matters." Much has changed since those words were written. Today six harbors shelter over five thousand boats. On any given summer day, thousands of boaters sally forth onto the lake for day sailing, cruising, and yacht racing.

Organized boating began in 1875 with the establishment of the Chicago Yacht Club. It is the oldest yacht club on Lake Michigan. The Columbia and Jackson Park clubs followed later in the 19th century and helped to pioneer racing and cruising off Chicago. By the 1940s there were eight private yacht clubs along the Chicago shore.

The highlight of the boating season in the Windy City is the Chicago-to-Mackinac Race. From its humble beginnings in 1898, the race has become a gala occasion bringing together yachtsmen from all along the shores of the inland seas. The 331-mile race is one of the oldest and longest cruising races in the world.

The perennial problem of Chicago area boaters, going back to the 19th century, has been the shortage of mooring space. The great landfill projects of the 1920s and 1930s created new harbors all along the shore of the central city, but the demand for new slips has grown apace with each expansion. Lake Michigan is Chicago's great natural asset and the best way to enjoy it is from the deck of your own boat.

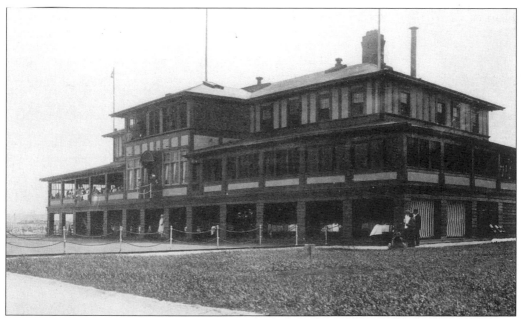

This is the Chicago Yacht Club clubhouse as it appeared in 1927. It was located at Monroe Street and Lake Michigan. (Courtesy of the Chicago Yacht Club Collection.)

For most of the 19th century, small boat sailors enjoyed the protected waters off Monroe Street. The Illinois Central Railroad grade acted as a breakwater for small sloops as pictured here in an 1886 stereoscope.

Monroe Street harbor in 1907 was a popular mooring place for Chicago boaters.

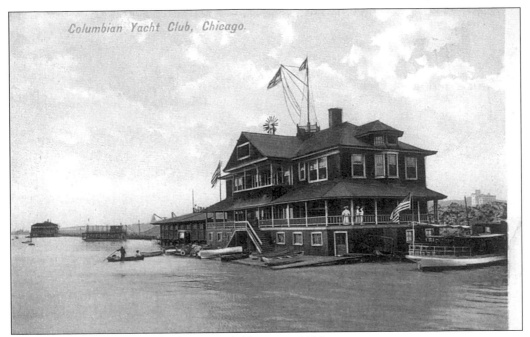

The Columbia Yacht Club built a new clubhouse in 1900.

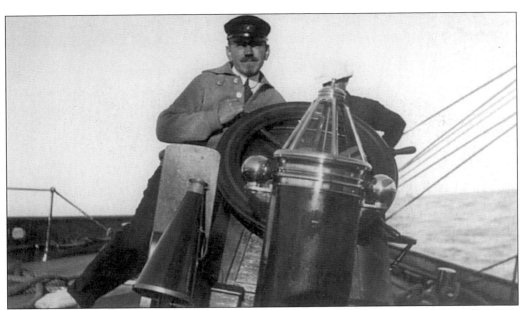

Commodore W.L. Baum of the Chicago Yacht Club is pictured above at the helm of his 110-foot schooner *Amorita*. Baum was one of the founders of the Mackinac Cup race. (Courtesy of the Chicago Yacht Club Collection.)

Concrete Super-structure, North of Washington Street,
Contract #5902 — Grant Park Bulkhead, Great Lakes
Dredge & Dock Co., — October 7th, 1924.

K-1854
CHICAGO ARCHITE
PHOTOGRAPHING (

Good harbor facilities were necessary to save boaters from the yacht-wrecking storms such as the autumn 1924 gale that ruined this two-master. Note in the background the naval training ship *USS Wilmette.*

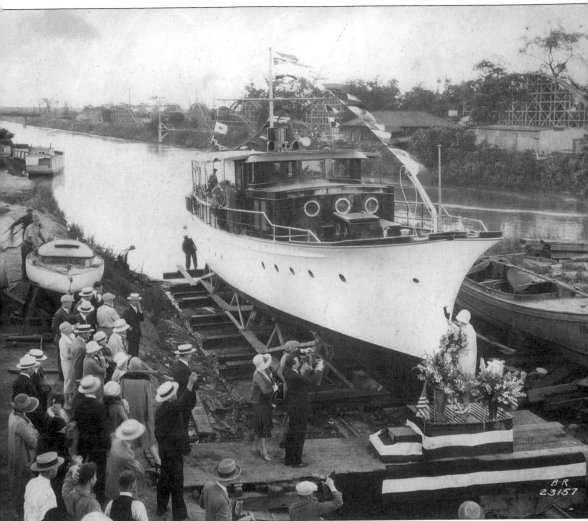

Fine yachts such as this were built and launched at Grebe's Yacht Yard, located on the North Branch of the Chicago River. In the background is the Riverview Amusement Park. (Courtesy of the Chicago Yacht Club Collection.)

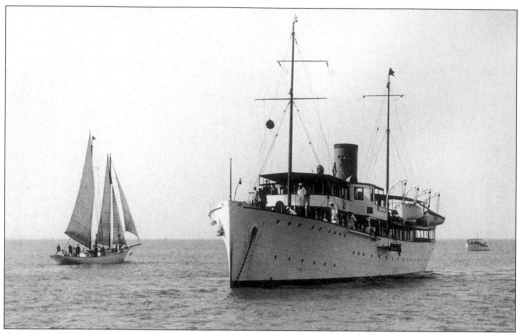

One of the largest yachts in Chicago was the *MisPah*. Vessels this large were moored in the Chicago River when not cruising the Great Lakes. (Courtesy of the Chicago Yacht Club Collection.)

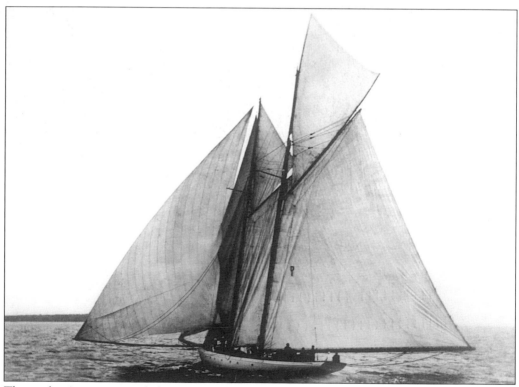

The yacht *Amorita* spreads her wings off Chicago in about 1911. (Courtesy of the Chicago Yacht Club Collection.)

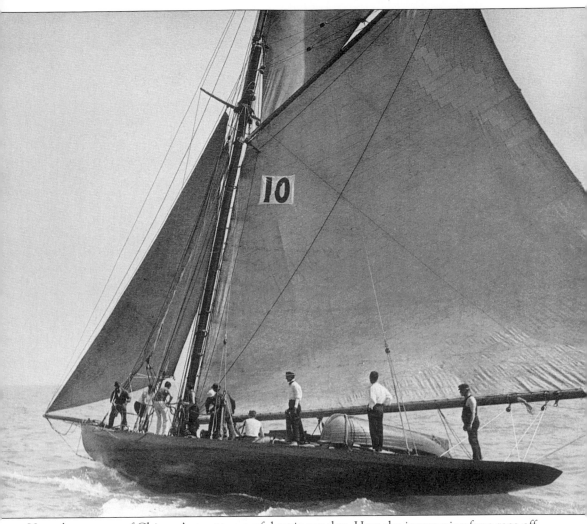

Vencedor was one of Chicago's most successful racing yachts. Here she is preparing for a race off Chicago in 1904. (Courtesy of the Chicago Yacht Club Collection.)

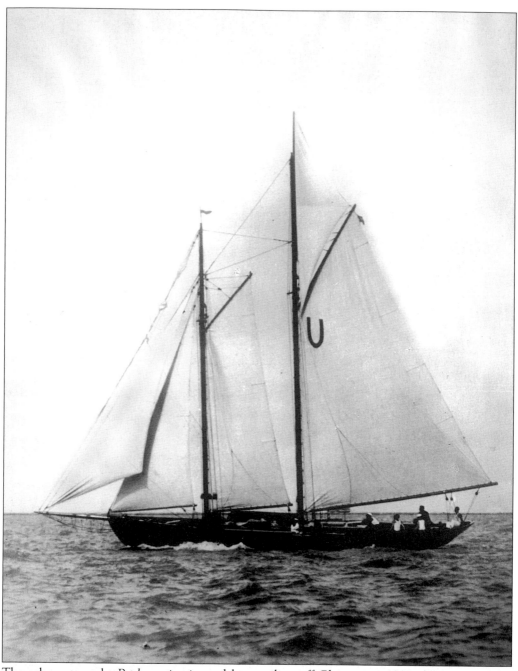

The schooner yacht *Bagheera* is pictured here sailing off Chicago in 1930. (Courtesy of the Chicago Yacht Club Collection.)

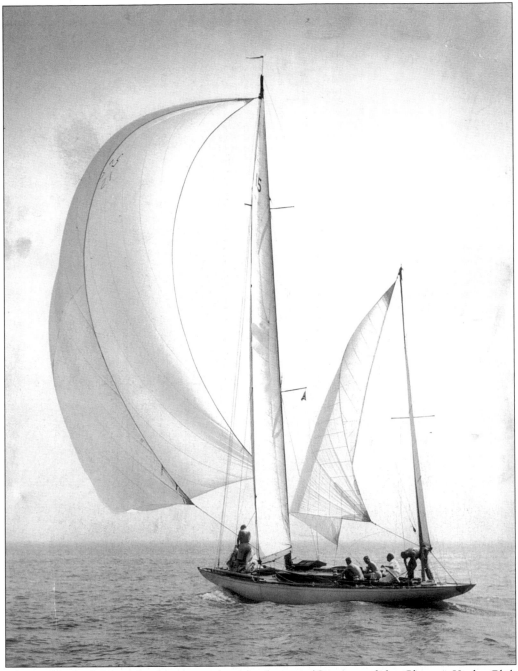

This is the yawl *Cara Mia* running with spinnaker set. (Courtesy of the Chicago Yacht Club Collection.)

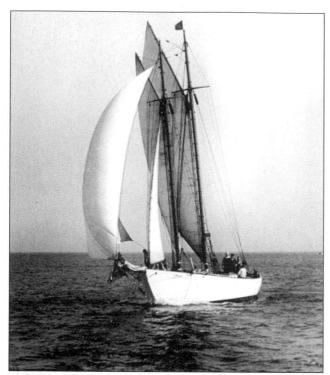

A schooner class yacht is pictured at left sailing off Chicago in 1932. (Courtesy of the Chicago Yacht Club Collection.)

The Chicago-to-Mackinac Race has been held since 1898. Here the crew of the 1942 winner *Falcon II* accept the Chicago-Mackinac Trophy. (Courtesy of the Chicago Yacht Club Collection.)

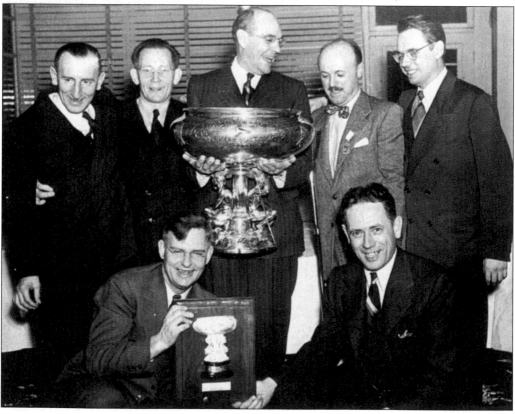

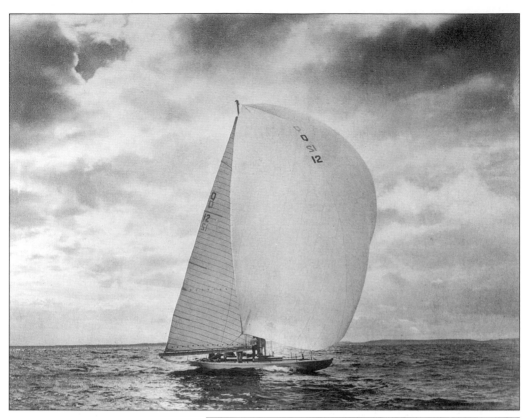

The "Q" class yacht *Gale* won the annual Mackinac race in 1950 and 1951. (Courtesy of the Chicago Yacht Club Collection.)

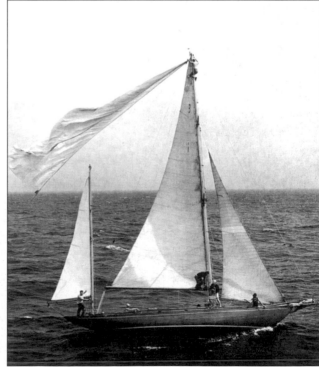

The yacht *Rubaiyat* was in the midst of the 1949 race when she lost her spinnaker sail. Note the yachtsman at the top of the foremast. (Courtesy of the Chicago Yacht Club Collection.)

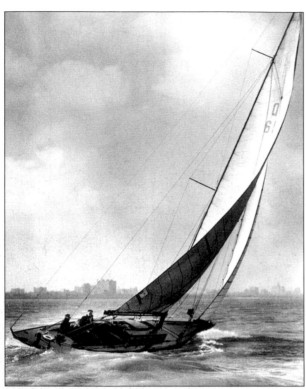

The "Q" class sloop *Intruder* raced for many years off Chicago. (Courtesy of the Chicago Yacht Club Collection.)

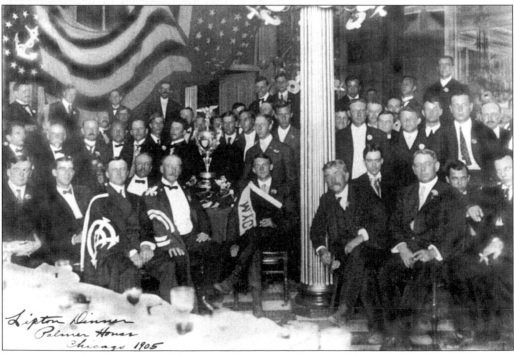

Yachtsmen gathered for the 1905 Lipton dinner at the Palmer House. Sir Thomas Lipton was a British merchant and sailing enthusiast who made five unsuccessful attempts to win the *America's* Cup.

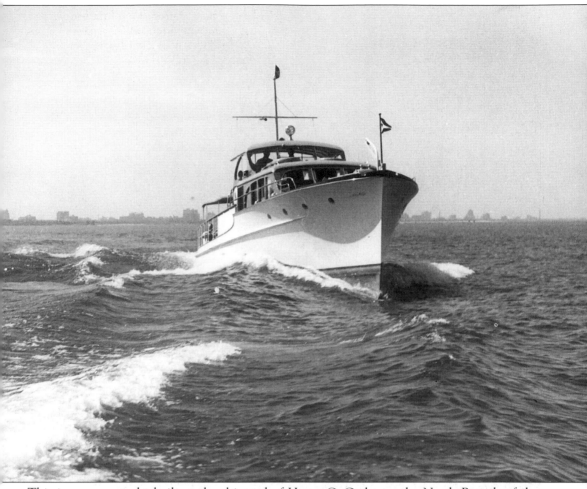

This is a power yacht built at the shipyard of Henry C. Grebe on the North Branch of the Chicago River.

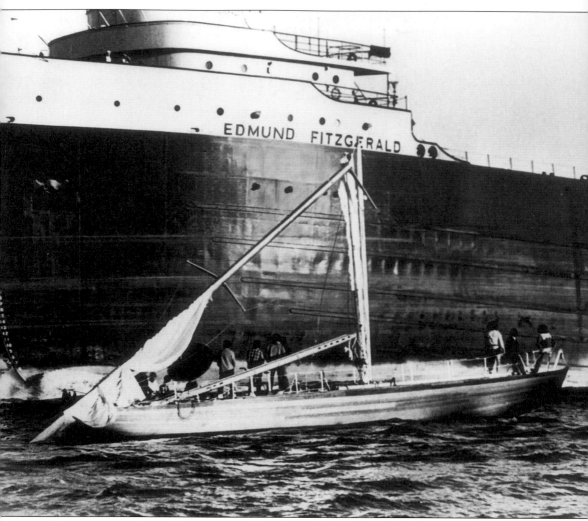

This is a reminder of the power of the Great Lakes, as the *Edmund Fitzgerald* passes the dismasted yacht *Heritage* four years before the great vessel was lost on Lake Superior in 1975.

Nine

MAKING A MODERN PORT

The key to Chicago's maritime development has always been the city's strategic location, where the fingers of the great Mississippi River system (in the form of the Des Plaines River) reach closest to the Great Lakes. Today maritime commerce remains a vital part of Chicago because of a complex network of harbors, canals, and rivers that together make up the modern port.

The old Chicago River port went into eclipse in the first decades of the 20th century, when many of the old heavy industry business relocated from the center city to the margins of the metropolis, and ship sizes became too great for the narrow downtown waterway. South Chicago, where the Calumet River enters Lake Michigan, became the new hub for the ore carriers and grain ships. In 1869 the U.S. Army Corps of Engineers first began to improve the Calumet River and make it an effective harbor. The decision of George Pullman to locate his model town and car works near Lake Calumet and the move of the giant North Chicago Rolling Mill to the mouth of the Calumet River signaled the emergence of the region as an industrial center.

While the Chicago River continued to play a minor role in commerce, the growth of Calumet Harbor made it necessary to adapt the area's inland waterways to the needs of the rapidly expanding Chicago area. In 1900 the Metropolitan Sanitary District succeeded in permanently reversing the flow of the Chicago River. Since the late 1860s city engineers had used pumps to draw water from the river into the old Illinois and Michigan Canal, thereby reversing the flow. The Chicago and Sanitary Canal improved on that by creating a wider and deeper waterway to pull clean water from Lake Michigan. In 1913 the Corps of Engineers linked the Sanitary Canal to Calumet Harbor by means of the 16.5-mile Calumet Sag Channel. This meant that barges coming up the Mississippi River system need not go into the Chicago River at all but that they could go directly to Lake Calumet.

Today Chicago is not what it was at the beginning of the 20th century, one of the greatest ports in the world. Yet the city's diverse collection of waterways and harbor facilities ensures that maritime commerce continues to be a vital part of the regional economy. Chicago endures as a shipping center.

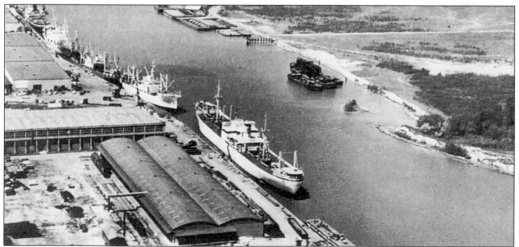

This is Lake Calumet Harbor as it looked in the early 1960s.

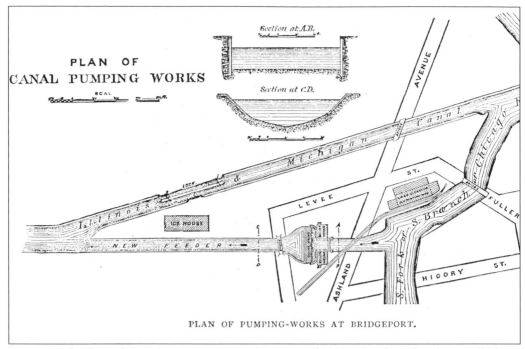

PLAN OF PUMPING-WORKS AT BRIDGEPORT.

Reversing the flow of the Chicago River—making it run backwards—has often been called one of the great feats of civil engineering. This was first done in the 1860s by means of pumps.

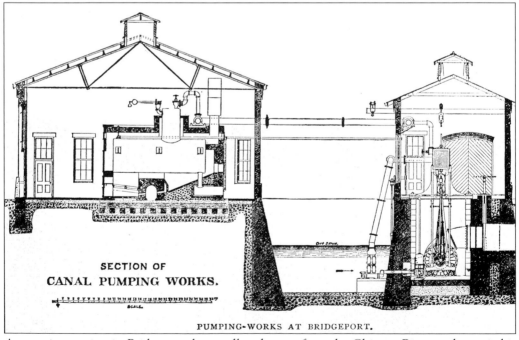

PUMPING-WORKS AT BRIDGEPORT.

A pumping station in Bridgeport drew polluted water from the Chicago River and emptied it into the Illinois and Michigan Canal. This created a current in the river toward Bridgeport and away from the lake. The goal was to keep the river from contaminating the city's Lake Michigan drinking water supply.

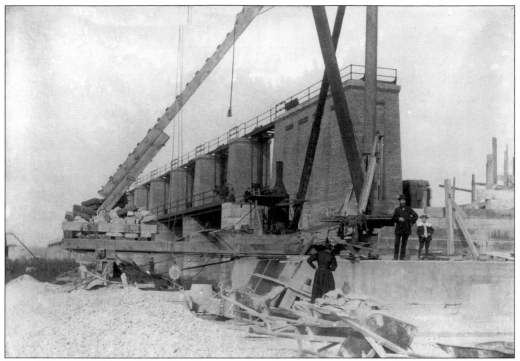

To permanently reverse the river, a new deeper canal was dug between 1886 and 1900. The key to the operation of the Sanitary and Ship Canal was the dam at Lockport, where a power plant and controlling works regulated the water levels on the main channel. (Courtesy of the Canal Archives, Lewis University.)

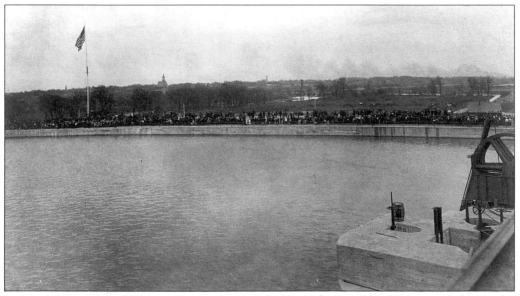

In May 1900, Admiral George Dewey, hero of the Spanish-American War, presided over the gala opening of the Lockport controlling works. A half-century of litigation brought by Great Lakes states against Chicago for diverting Lake Michigan water followed the opening ceremony. (Courtesy of the Canal Archives, Lewis University.)

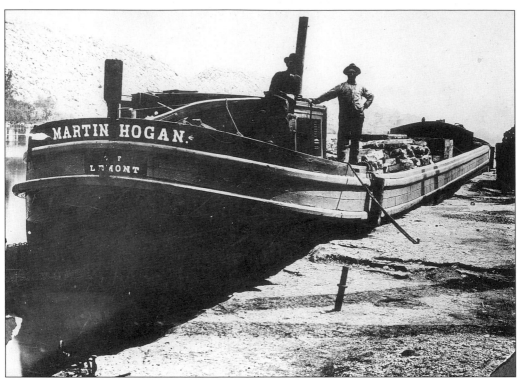

The canal boat *Martin Hogan* used the new Sanitary and Ship Canal to carry stone from the quarries of Lemont to Chicago. (Courtesy of the Canal Archives, Lewis University.)

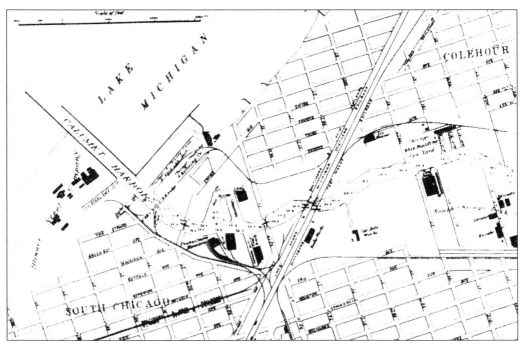

This 1898 map of the lower Calumet River illustrates the development of the region following improvements to the waterway made by the U.S. Army Corps of Engineers.

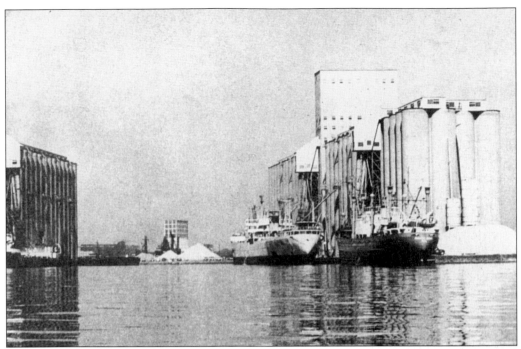

To build Calumet Harbor, the U.S. Army Corps of Engineers dredged the Calumet River, created three turning basins, and deepening Lake Calumet.

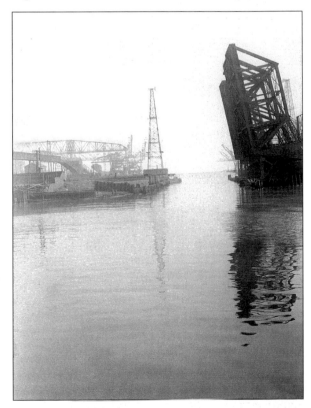

From its beginnings, Calumet Harbor was an industrial waterway, specializing in iron ore and coal, as well as grain.

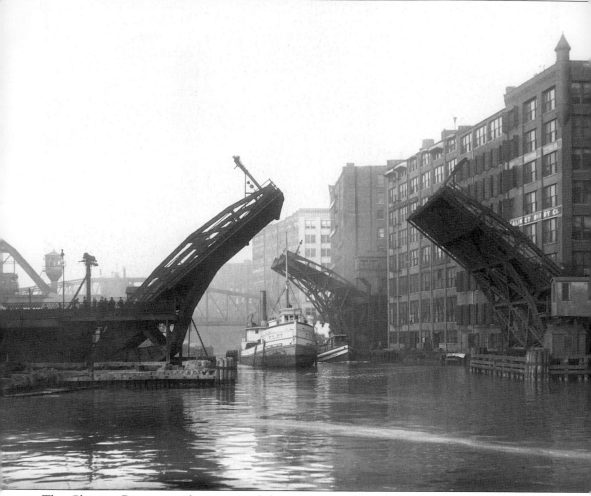

The Chicago River was also improved for commerce during the first decades of the 20th century. Rolling-lift bridges, and later bascule bridges, replaced the swing bridges that partially blocked the channel.

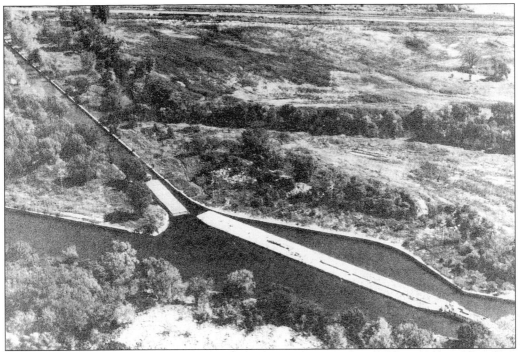

The original Calumet-Sag Channel, pictured here at its junction with the Sanitary and Ship Canal, was completed in 1922. It allowed barge traffic on the Illinois River to bypass Lake Michigan when bound for the Calumet Harbor.

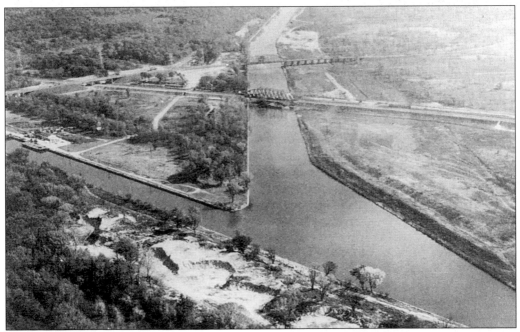

Between 1955 and 1971, the Corps of Engineers widened the 16-mile Calumet Sag Channel from 60 to 225 feet. Today the channel draws traffic from 12,000 miles of inland rivers and canals.

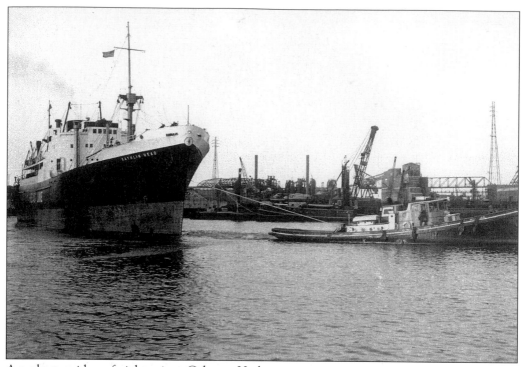

A tugboat guides a freighter into Calumet Harbor.

Great fanfare greeted the opening of the St. Lawrence Seaway in 1959. It was hoped that the improved locks linking the Great Lakes and the Atlantic Ocean would revive the Port of Chicago.

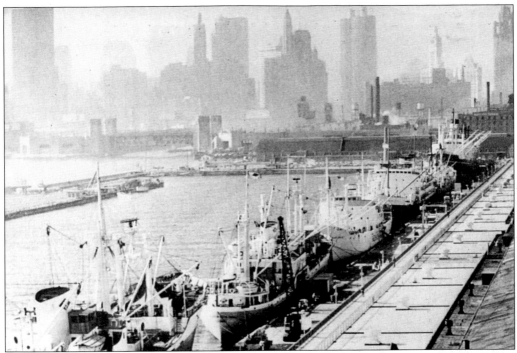

Navy Pier was refurbished for the expected traffic from the Seaway. It was not uncommon during the early 1960s for 250 ships a year to dock at the pier. By 1974 that number fell to 20.

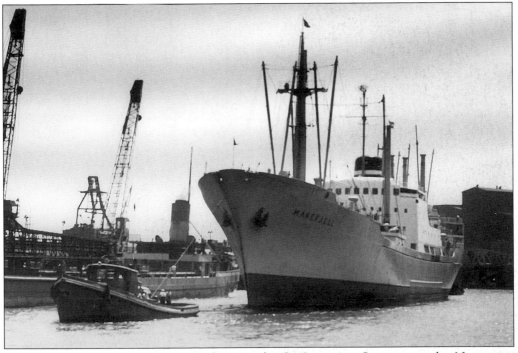

The first ship to enter Calumet Harbor via the St. Lawrence Seaway was the Norwegian freighter *Makefjell.*

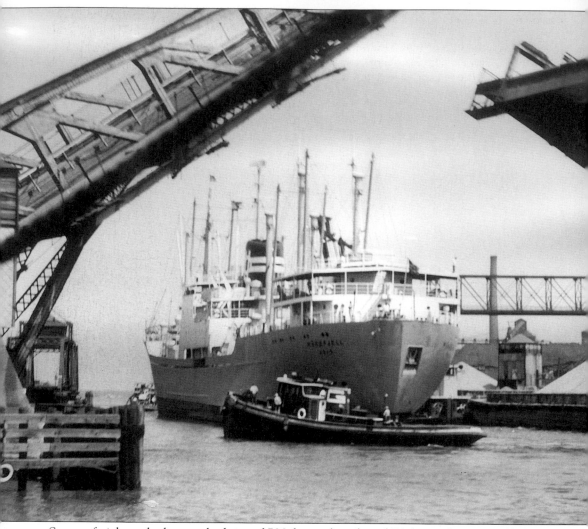

Seaway freighters had a standard size of 730 feet in length and 70 feet in beem, established by the size of the locks of the St. Lawrence Seaway.

During the busy years of the 1960s, the Seaway led to the establishment of regularly scheduled commercial sailings between Chicago and Europe. The Hamburg Chicago Line was one of the regular visitors to Lake Michigan.

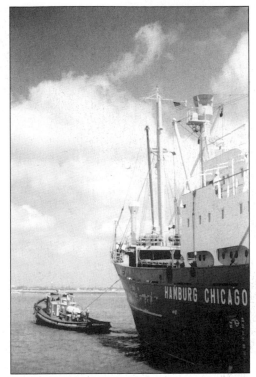

Most Seaway ships were general cargo vessels. They brought wide varieties of manufactured products, from cars to toys, as well as agricultural products, from Japanese soybean oil to Dutch cheese.

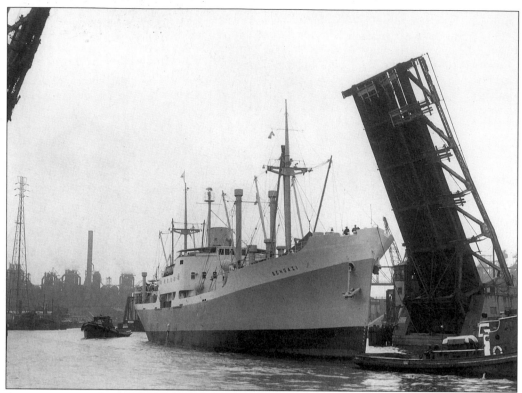

An unanticipated side effect of bringing ocean-going vessels into the Great Lakes has been the invasion of exotic species into Lake Michigan. In the 1950s, the sea lamprey devastated the indigenous lake trout. More recently, zebra mussels from the Baltic Sea have entered Chicago waters, and have quickly begun to alter the ecosystem.

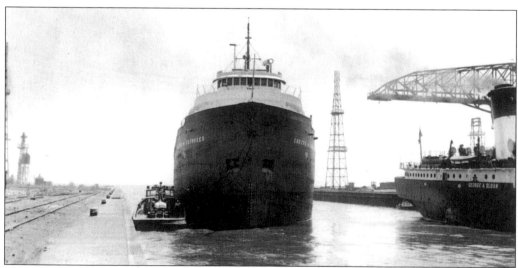

The annual traffic at Calumet Harbor averaged nearly 29 million tons between 1965 and 1974. During the 1990s, however, the harbor became much less active as nearby ports such as Burns Harbor, Indiana Harbor Ship Canal, and Milwaukee captured the bulk of the ship traffic head for the southern end of Lake Michigan.